D1028972

LOVE ME LIKE YOU HATE ME

LESSONS IN PLEASURE AND PAIN

LOVE ME LIKE YOU HATE ME

LESSONS IN PLEASURE AND PAIN

Venus O'Hara · Erika Lust

FEMME
Fatale

International edition:
© 2010 Tectum Publishers NV
Godefriduskaai 22
2000 Antwerp
Belgium
Tel.: +32 3 226 66 73
Fax: +32 3 226 53 65

© 2010 Venus O'Hara, Erika Lust

ISBN: 97-894-90822-06-4
WD: D/2010/9021/42
(FF007)

Editorial coordinator: Antonio Lamúa
Design and layout coordination: Claudia Martínez Alonso
Layout and pictograms: Guillermo Pfaff Puigmartí
Translation: Cillero & de Motta

Editorial project:
© 2010 HUAITAN Publications, S. L.
Via Laietana, 32, 4ª planta, oficina 92
08003 Barcelona
Spain

Printed in Slovenia

>>> Introduction

We both consider ourselves to be feminists, but that doesn't make us any less feminine, sensual or sexual. Sometimes we enjoy dominating others and, at other times, we enjoy being dominated ourselves. This book provides a modern perspective on a variety of practices that may be considered taboo for many women: to be tied up oneself or to tie someone else up, role-play and dressing up, giving pain or receiving it, being a strict dominatrix or being a submi-ssive slave, punishing our partner or being punished by them...

We consider feminism to be open to misinterpretation when applied to the bedroom. Many women still imagine that being intelligent, modern and a feminist must be incompatible with becoming involved in such practices, acts often wrongly per-ceived as being dangerous for a woman's physical and moral integrity. We tend to disagree. We also know that many men are concerned that their motives for being interested in this alter-native world of pleasure might be misunderstood and that they could be perceived, wrongly, as being macho, controlling or domineering. It is important to understand that these practices are just part of a larger game of shared pleasures that has noth-ing to do with violence of any kind. In many cases, the opposite is true; many role-play games can permit us to discover things about our partners and ourselves that we never knew before, and they open up a new universe of unimagined experiences and unparalleled sensations. We invite you to indulge yourself in the pages of *Love Me Like You Hate Me* with an open mind and a willingness to learn. We also invite you to enjoy the silk handcuffs from Bijoux Indiscrets enclosed with this book with our compliments. You can experience being tied up yourself or experiment with tying someone else up and begin, at once, to explore the seductive thrills of domination or the fear and excitement that only submission can provide.

—Venus O'Hara and Erika Lust

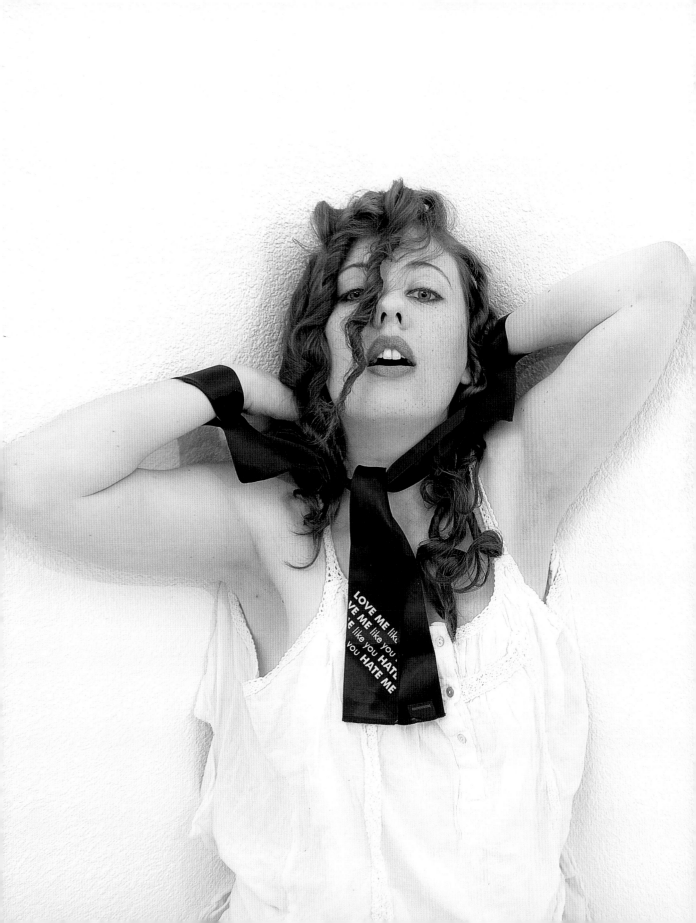

>>> Origins: De Sade and Masoch

Before we open the door that leads into the new world of *Love Me Like You Hate Me*, it will be necessary to establish some fundamentals. We shall begin by studying the origins of the subject and continue by learning the vocabulary that you will need to better understand this world. Any trepidation and fear you may have will be removed by the simple expedient of a few key terms.

Sadism

Sadism: the tendency to derive sexual gratification or general pleasure from inflicting pain, suffering, or humiliation on others. The term "sadism" derives from the erotic writings of Marquis de Sade.

Donatien Alphonse François de Sade, Marquis de Sade (2 June 1740 – 2 December 1814) was a French aristocrat and writer notorious for his libertine sexuality and lifestyle. He is best known for his provocative erotic novels. His works often depicted violent sexual fantasies with emphasis of humiliation, criminality and blasphemy. Sade's works have often been viewed as an example of sexual and political freedom. In 1784 whilst a prisoner at the Bastille in Paris he wrote *The 120 Days of Sodom*, an underground classic. He was released from the insane asylum at Charenton on April 2, 1790. The following year, at the age of 51, de Sade published *Justine* (1791). In the sequel, *Juliette* (1797), the heroine was Justine's sister, who enjoys the delights of evil. His novels include: *The 120 Days of Sodom* (1785), *La Nouvelle Justine* (1791), *Aline and Valcour* (1793), *Philosophy in the Bedroom* (1795), and *Juliette* (1797).

Justine

Justine is de Sade's most famous work, of which he wrote an early version in the Bastille and finished it while free. *Justine* follows the journey of a 12 year old girl's sexual life until the age of 26. Justine is given the name "Thérèse" and is constantly subjected to abuse, countless orgies, punishment and corruption.

She is wrongly accused of theft and sent to jail, from which she eventually escapes. In her search for work and shelter she often falls into the hands of perverts who take advantage of her. In de Sade's philosophy God is evil and the misfortunes suffered by Justine are a result of denying this truth.

Masochism

Masochism: the tendency to derive pleasure from one's own pain or humiliation. Masochism is the opposite of sadism. While the latter is the desire to cause pain and use force, the former is the wish to suffer pain and be subjected to force.

The term derives from the novel *Venus in Furs* by Sacher-Masoch (Lemberg, 1836-1895). His paternal aunt, who lived with his family during his childhood, was the Countess Xenobia. Sacher-Masoch adored her and was enraptured by the beatings she gave him. It was to these experiences that his later fascination with being dominated by women was attributed. During a liaison with Fanny Pistor, a submission contract was signed in which Leopold von Sacher-Masoch became her slave for six months.

Some of his works include: *Venus in Furs* (1870), *The Legacy of Cain* (which appeared in four volumes from 1870 to 1877), *False Ermine* (1873), *The Messalinas of Vienna* (1874), and *Die Schlange im Paradies* (The Snake in Paradise, 1890).

Venus in Furs

Venus in Furs is the story of Severin, a man who is so infatuated with a woman that he requests to be her slave. At first she does not understand his request but gradually she sees its advantages, although at the same time she resents him for allowing her to do so. Severin describes his feelings during these experiences as suprasensuality.

COMMONWEALTH UNITED Presents

VENUS IN FURS

The coat that covered paradise, uncovered hell!

A Masterpiece of Supernatural Sex!

STARRING

JAMES DARREN · BARBARA McNAIR
MARIA ROHM as "VENUS"

COLOR

co-starring KLAUS KINSKI □ DENNIS PRICE □ produced by HARRY ALAN TOWERS □ directed by JESS FRANCO □ music by MANFRED MANN & MIKE HUGG □ released by COMMONWEALTH UNITED

COPYRIGHT © 1970 COMMONWEALTH UNITED CORPORATION

70/137

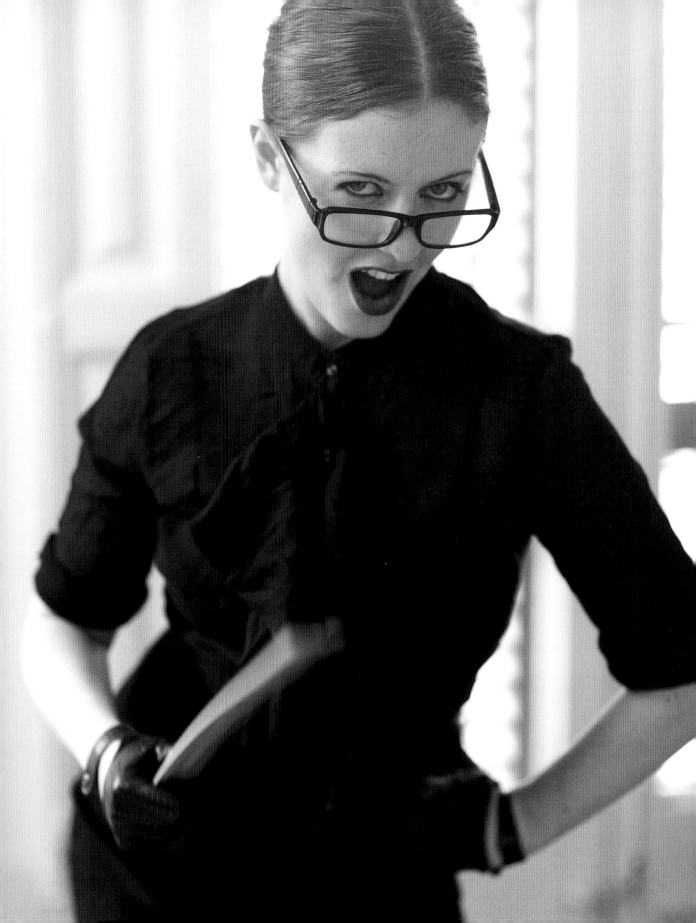

>>> Terminology

You may have heard some of the following terms, but never really knew what they meant. Check out our basic guide to fetish speak.

BDSM: stands for bondage and discipline, dominance and submission, sadism and masochism.

BONDAGE: the practice of restricting a person's bodily movements for erotic pleasure.

DISCIPLINE: discipline can be used in a system of training. It can also be what happens when someone misbehaves.

DOMINANCE: taking the dominant role. Controlling the submissive's behaviour. It can be role-play or standard in a dominant-submissive relationship.

SADOMASOCHISM: any activity or practice involving the inflicting or receiving of pain.

DOMINANT (also dom, domme): the one in charge.

SUBMISSIVE (also sub): the one who gives themselves freely for the pleasure of another.

SADIST: an individual who enjoys causing pain.

MASOCHIST: an individual who enjoys receiving pain.

TOP: a dominant.

BOTTOM: a submissive.

MASTER (male)/MISTRESS (female): dominant, controlling partner in a dominant-submissive relationship. Mistress is synonymous with dominatrix.

SLAVE: a totally subordinate person who needs to be owned and to serve. A slave questions nothing and demands nothing in return.

SWITCH: an individual who "switches" between dominant and submissive roles. A switch can be both a sadist and a masochist.

DUNGEON: any place specifically intended for BDSM play. Could be equipped with furniture such as crosses, etc.

SAFE WORD: a word or phrase used to stop a BDSM game. Safe words are defined beforehand and should be respected by the dominant. A common safe word is "red" (stop) or "yellow" (approaching the limit).

VANILLA: refers to non-BDSM sex; "vanilla sex." A person who doesn't do BDSM is a "vanilla."

FETISH: 1. Officially, a conventional product whose existence acts as a catalyst for increased sexual stimulus and an improved orgasm; unconventionally, anything neutral that elicits a sexual response, as a shoe fetish or a fur fetish. 2. Anything that pertains to BDSM in general terms; as a fetish club or fetish party. 3. Objects, rituals, or attire that relate to BDSM, fetish photography, fetish clothing.

>>> Now you see me, now you don't
>>> Some ideas to get started
>>> Blindfold confession

BLINDFOLDS

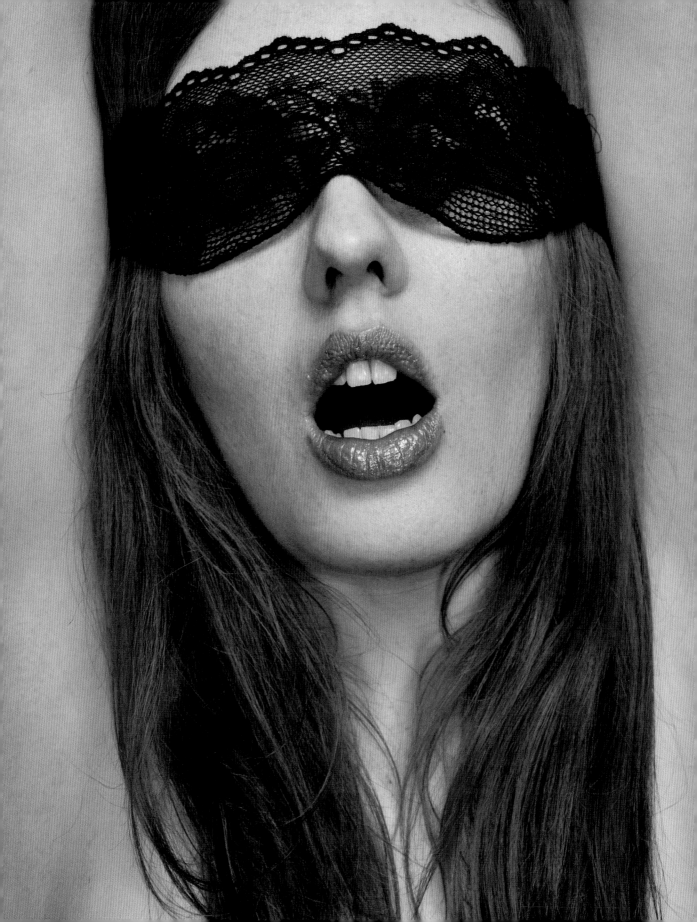

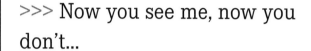

>>> Now you see me, now you don't...

A comfortable blindfold is definitely the first item you should use when initiating BDSM. Despite being a simple tool, its power shouldn't be underestimated. Wearing a blindfold enhances all the remaining senses, focussing attention on sound, smells and touch. Not knowing what to expect can cause greater excitement and anticipation for the wearer and give the nonwearer a greater sense of power and control of the situation.

The use of a blindfold is a great way to start practising both dominant and submissive roles.

>>> Some ideas to get started...

Equipment
You can either invest in a blindfold or use stockings, scarves and even neckties.

Massage
If you've never used a blindfold before, a good way to start is taking turns in giving each other massages. The person receiving the massage should wear the blindfold and just switch off, get used to being passive and enjoy not having to do anything back. For greater sensuality try burning scented candles and playing relaxing music.

Food
Blindfolds combined with food can be an incredibly sensual experience. It helps if you prepare the food in bite-size portions beforehand. Tease the blindfold wearer with the food by taking it away just when they're about to bite. Another teaser is to alternate sweet and salty foods.

Temperature play

Make yourself a hot cup of tea and prepare a glass of ice cold water at the same time. Take a couple of sips of the tea and, with your warm mouth, kiss, lick and devour your lover's body. Just when they're getting used to it, drink some of the ice cold water and continue.

Object

Take turns wearing the blindfold while letting the other do whatever they want. Being passive without the pressure of reciprocating can be great fun. Having all the control can be equally enjoyable. This is a great way to find out which role you prefer in a BDSM scenario. Are you top or bottom?

Discuss any limits beforehand and make sure you trust each other.

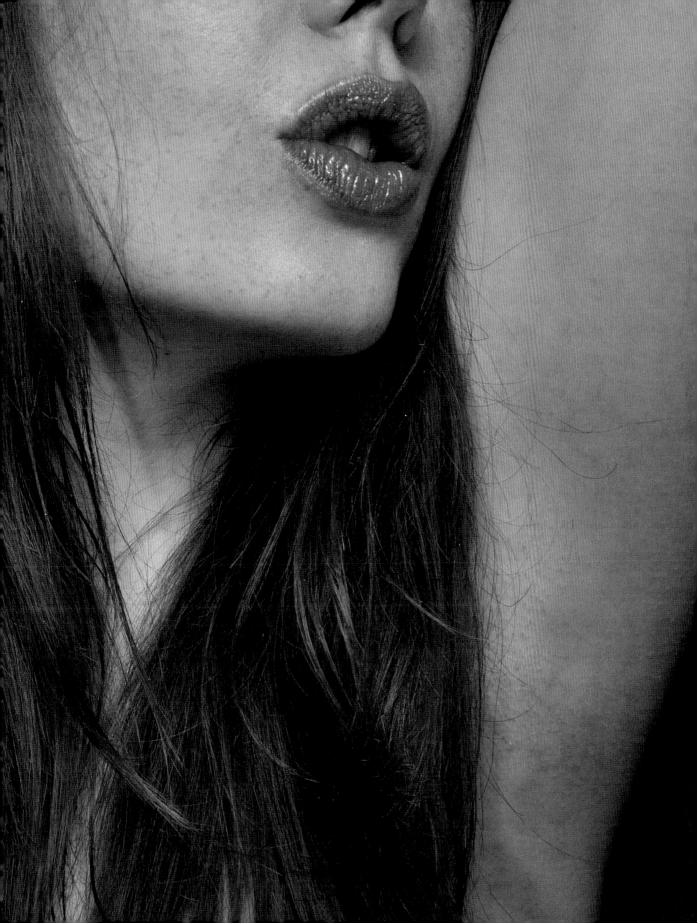

Trekking

had just emerged from the wreckage of a toxic relationship and, to wash myself clean, I placed an online ad to find some new people with similar interests to my own. I've always enjoyed trekking, so it seemed appropriate to use that as a spring-board to join a network who shared, I hoped, a genuine appreciation of my favorite pastime. To my delight, I had an instant and reassuring response and I was invited to join several organised trekking groups.

From my initial selection of prospective "trekkers," there was one guy who seemed of particular interest and, one evening, after maintaining a regular online correspon-dence for several weeks, we decided to meet for a drink the following day. To my surprise and profound interest, he was, in person, a great deal more apprehensive, restrained and serious than his instant messages suggested. I felt the urge to solve it to my satisfaction; so I decided to use a little ploy that I had achieved results with a few times in the past.

"Do you mind if I close my eyes for a few seconds while you tell me something about yourself. I just adore your voice," I explained. He nodded, smiled and, as I closed my eyes and feigned interest in his discourse about trekking, I listened for the gaps, pauses and inconsistencies in the melody his voice made. It only took a few seconds before I heard it; the tension underlying the words, delaying them. I smiled again as I opened my eyes and looked into his. As he nodded back I could see the vein pulsing in his neck, the subtle flare in his nostrils and the tremble in his lips as he spoke. He wanted me and, in his reluctance to let me see it, I found myself drawn to him and his contradictions.

The following night, we were messaging each other again and he confessed that he was highly attracted to me. I thought of the timid, repressed individual from the day before and the distance between that persona and this, disinhibited one was be-ginning to arouse me. I gave him some tentative compliments about his looks and advanced him the unspoken permission to reciprocate in a similar style. Very soon our correspondence turned towards our favourite sexual experiences and most in-tense private fantasies. My own preferred scenario was being entirely passive during the sexual act. I seemed to find a raw spot in him with that admission and he con-fessed that I had articulated an unrealised fantasy in him that he had harbored for many years. Our instant messages bounced back and forth with increasing speed, heat and urgency in complete contrast to the conversation from the day before. We arranged to meet at my apartment the next day to talk about our shared fantasy, in person, and I wondered which version of my "trekker" would show up this time. We met up at the nearest underground station to my home and, frustratingly, the social pleasantries we shared were as restrained and mechanical as they had been before. This time, however, the very discomfort he showed worked upon me like an erotic charm.

When we arrived at my apartment, I poured some wine and then began talking casually about my fantasies as we sat and drank. The warmth of the wine, the relax-ation represented by my environment and the proximity of my unravelling, trek-king tension-ball combined to invigorate my imagination and sensual ambitions.

The "shy guy" given the licence to unbutton his straitjacket of social programming began to be replaced by the emerging, online "stud ape;" piece by piece; sip by sip. Our first kiss freed him to become the primate I had always imagined him to be in reality; my front room became our sexual safari park for the whole day. The contrast between his public persona and online version maintained my interest despite everything. Only through the mediation of instant messaging could I give him instructions on how I wanted him to fuck me, bringing the subject up in the real world, without warning, seemed to disorientate him to a reliable extent.

It was then, through our virtual world of sexual negotiations, that he told me about a fantasy that had occurred to him and that he wanted to realise. He wanted me to visit his apartment, for the first time, and, before suffering the usual painful introductions to engage in sexual acts then and there. I agreed to the direction and the scenario. I wanted to be blindfolded and stripped before becoming his passive love doll. Understandably nervous as I stood outside the door of his apartment, hearing the thud of industrial rock music even through the wood, I rang the bell and waited; shifting my weight from high heel to high heel. After what seemed to be an interminable wait, a scraping sound from inside the apartment jarred my nerves, a hollow click startled me and the door opened a small degree. As I watched the narrow gap widen, my lover's pensive face appeared and I exhaled slowly. I was pushed back on my tottering heels by the weight of escaping incense; mixed sticks, no single aroma. He regarded me with a dispassionate regard, neglecting to speak as the scenario dictated, holding the moment for longer than was necessary, and then beckoned me inside with a dismissive shrug. Discomforted by this realisation of an imagined situation, I was unprepared for the sudden slam of the door behind me as I attempted to scrutinise the interior of his domestic space and shrieked when my back was pressed, abruptly, against the painted wood.

Any further expression of my surprise was forced from my mouth by his urgent lips and probing tongue. He disengaged almost at once, stabbed his arm over my shoulder and retrieved a purple silk scarf that hung from a hook behind me. With practised ease, he tied the scarf around my head and shut out the light completely. The pounding music seemed to increase in volume and shouted its threats from every direction and my clothes were stripped from me in a rush of hasty unfastenings, quick openings and impatient rips. As my naked skin rose in a myriad of goosebumps, I felt his stubble graze my soft neck and his hot breath caress my cheek. "Don't move, I'll be back in just a minute," the confident voice whispered.

The longest minute of my life commenced in a vacuum of sensory confusion. In the absence of definitive sight, reliable smell, coherent sound, empirical touch or taste, beyond the metallic sting of my panting breath, my entire world was reduced to the sensation of soft, carpeted, floor beneath my twisting feet. I could have been standing anywhere, naked, vulnerable and dependent; anywhere at all. Before I had realised he was there, he grasped my hands, held them together and handcuffed me. With a sudden pull on my new bracelets, he dragged me forward into another part of the darkness I was alone in. I imagined that I heard a door opening. The volume of atonal shrieking and feedback increased. I turned a corner, felt the backwash of another door opening, and was deafened by the full volume of the music. He released his grip on my handcuffs and I stood, trembling and sweaty, in another unknown space for several minutes, abandoned again. In the absence of any information to the contrary, my mind began to run through variations of

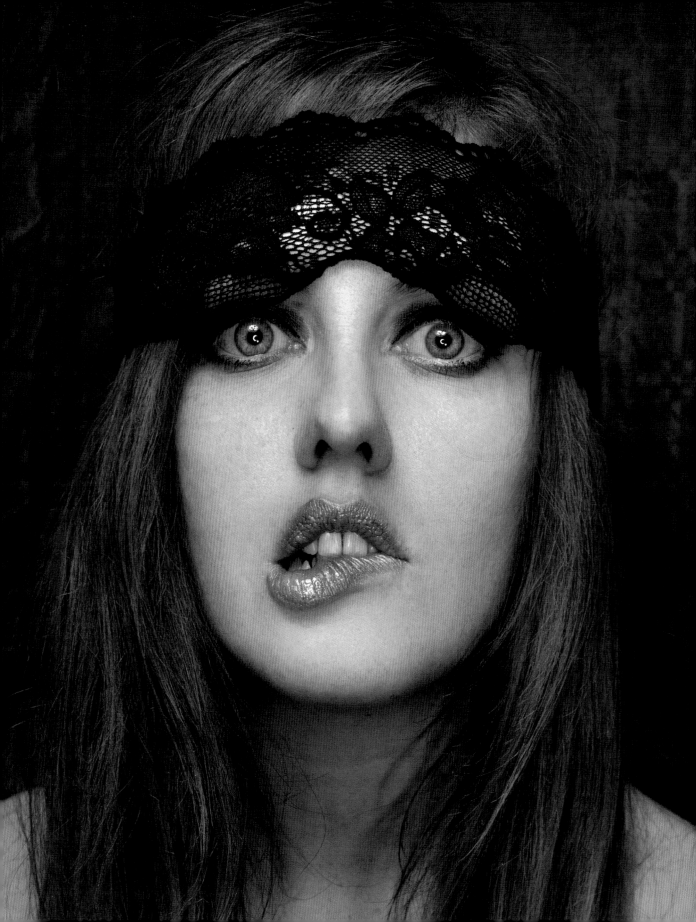

potential audiences that could, at that moment, be watching me from their seats observing me. He gripped my shaking shoulder and urged me down towards the floor and whatever it contained. The rough mattress that intercepted my knees was a blessed relief as I had anticipated the hard kiss of a tiled floor or bare wood of cheap floorboards. His hand pushed me, face down onto the uncovered surface and began the rough exploration of my body with eager and untutored enthusiasm. I was his creature, his pet and his object. He had unwrapped me, positioned me and was now consuming me with touches, pinches, caresses and rubbings. The frequent pauses and abandonments were just as intoxicating, as were the ice cubes, textured gloves, warm licks and delicate strokes of a single fingertip. My tense pleasure was building and the heat, imprisoned between my legs began to surge up my spine towards my brain as well as coiling in my sex. I was nothing, pliable, passive, used and ready. As a tingle began to grow in my thighs, I was pushed down further into the mattress, my cuffed hands trapped beneath my squashed breasts, as his voice crackled in my ear.

"Can I put the condom on, now?," he asked.

The temperature, so carefully and skilfully built-up inside me dropped a few degrees with disappointment as I nodded my unnecessary consent. I had expected his penetration to occur with no warning and the sex to commence as part of the mystery. Under a blindfold, in an unknown room in a barely glimpsed house, strange invasive hands on an unseen mattress followed by an urgent mysterious thrusting would have been perfection in my passive condition. Now, with the bubble of fiction burst apart, it only remained to derive the most pleasure from the situation as possible. He removed the handcuffs from my pliant wrists and I was secretly relieved to be free of the discomfort. After we had come in our separate imaginary worlds, he withdrew and smoothed the blindfold from my face with attentiveness and delicacy. The room, of course, was not as I had imagined it; because it lacked priests, pensioners or blood relations. It was merely predictable in every respect. Although we met again over the course of the subsequent weeks, the thrill had gone and I was ready to resume a more regular romantic life. As irony would have it, I never did go trekking with my "shy guy," but he did show me the way towards something much more significant. I used to be a slave to my senses; now I use my senses, or lack of them, to make me into a better slave. You can see yourself much

BONDAGE

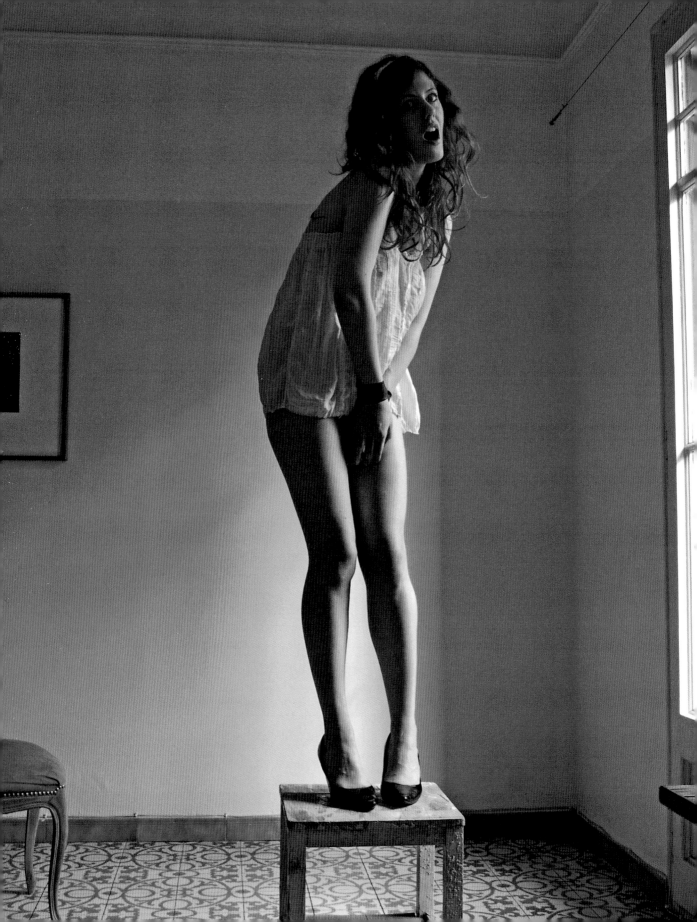

>>> # What is bondage?

Bondage involves tying up or restraining someone to induce sexual pleasure. For the person being tied up, it means you can relax and enjoy receiving pleasure without having to worry about giving any back at the same time. For the person performing the bondage the sight of your partner in a vulnerable position can be a turn on as well as experiencing increased feelings of power, but, of course, this power must never be abused. Whether you're on the giving or receiving end of bondage discipline, you can get lost in a whole new world of sexual fantasies.

Tip: using a blindfold as well as restraint can heighten other sensations in the body.

Trust and safety

Bondage is about trusting your partner enough to let them tie you up and do what they like to you, or vice versa. It's imperative you talk about what is or isn't going to happen. If you don't like pain, then agree not to go there.

Safety tips

Before you start, it is essential to establish some basic ground rules. You should discuss some boundaries with your partner to make sure that you're both on the same wavelength.
- Discuss where you are willing to be tied (i.e., only arms, no legs); maybe you want to pretend to be tied initially, to see if you like to be restrained.
- Discuss what you are willing to have done when you are tied up.
- Don't try bondage with someone you've just met.
- Never let a partner bully you into something you don't want to do. Be clear about what you will and won't allow.
- Discuss what sensations you absolutely hate or make you uncomfortable (i.e., no hot wax, no sex toys, etc.).
- Discuss what you plan to do beforehand. These rules are sacred and must never be broken during a game.

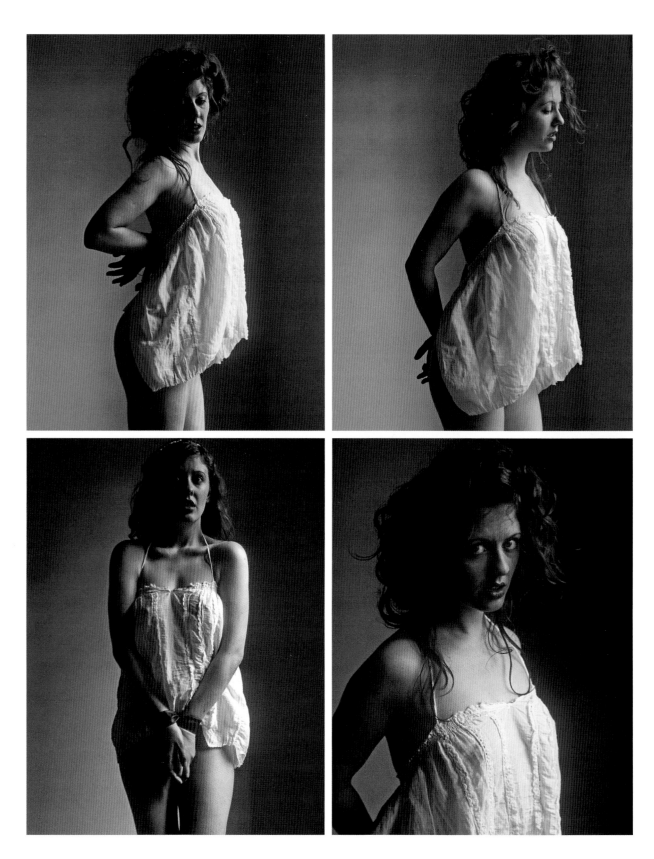

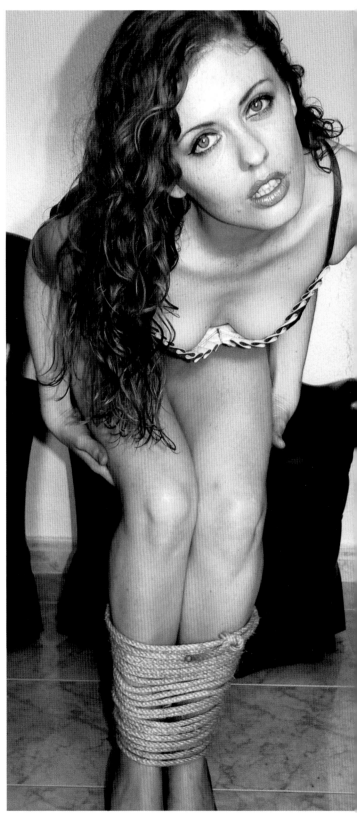

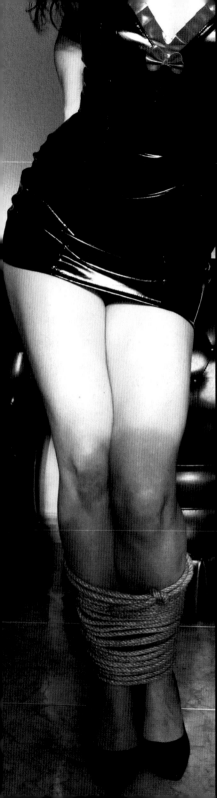

Brown paper bag

I almost needed a bag to help me breathe when I saw him that first time. wanted to swallow every superlative I'd ever uttered as being below him. He was in his final year and his attitude, self-containment and confidence was compulsive to behold. I was still a first-year student, inexperienced in vita areas and well aware of it. As luck would have it, I fell into a debate at the student union bar and, by verbal nerve, I attracted attention from the more seasoned regulars; from him, in particular.

Later that same evening, I was regarding my untried nakedness in my ward-robe mirror and wondering whether anyone else in the bar could vouch tha he'd asked me out on a date with him. I found out that he had; it was all tha mattered. The fetters in my mind fell apart when, after two weeks of dating we became intimate. I remember the rush every time I thought about hi hairless body and the furnace between my thighs whenever he called round to my halls of residence; which was almost as often as I wanted. Sex began and ended with his presence in my bed, his urgency between my legs and his stiff ness; swelling, sliding and surging inside me. He was my glowing centre and my defining principle. My stomach flipped and twitched every time we me with my abiding hope that we would fold ourselves into each other withou delay being uppermost in my mind. It was inconceivable that I could functior independently without him even when his behaviour towards me worsened ir small, but vital, degrees.

"Okay if I get myself a porn mag?," he muttered one afternoon outside the newsagent.

My face burned with a mixture of disbelief and exasperation, but I just nodded as he disappeared into the shop and reappeared with a brown paper bag. I sa in silence on the bus back to campus as he browsed the pages of the magazine in full view. I had to hold the empty paper bag as he indulged himself; he tol me not to drop it before pushing a photo-spread under my nose.

"Look at her, I'd let her handcuff me any day!" He laughed too loudly.

My fixed smile wavered when my lover left to study his Masters degree ir another city. The gaps between our, ever more occasional, weekends togethe seemed to widen. When I was with him, in his clearly defined space, it wa as it had always been between us, but when he stayed at my place it was as i hostilities had broken out between divergent nation-states.

My flat-mates hid and waited for the alcohol-fueled skirmishes to be initi ated between us before the verbal artillery barrages commenced in earnest Even when a truce was signed with caresses, sealed with sex and ratified witl orgasms in the middle of the night, it only meant another wasted weekend fo my fellow scholars.

I flaunted my independence by halting one of our incendiary rows with th demand that he just crawl back to London. He shocked me by begging m not to leave him. In spite of the carnality that bound us together like leathe straps, he continued with his routine of bad behaviors. Subtle insults, smoot

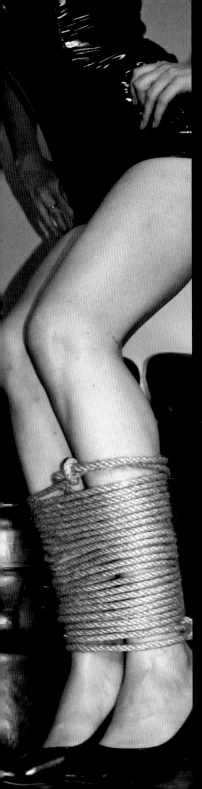

nummation and blunt jibes about my body were applied by him, in rotation but I was becoming inured to his little betrayals by now. In every sense that mattered, I had outgrown him but my fear of taking the next step overrode my intuition. He was still my first and only lover. It was while we were ordering food at an Italian restaurant that something changed. He disappeared from the table and, after I had ordered, he reappeared with a brown paper bag. I unpacked it at his place and laid out the contents for my own scrutiny and his interest. I felt the shiny surface of the PVC basque, stroked the tooling along the thigh-high boots, frowned at the handcuffs and held a smooth stocking against my soft cheek.

"Put it on" His smooth voice was mesmerising.

I assessed my nakedness in his bathroom mirror before I attached the hooks and eyes in the back of the basque and adjusted the lacing to build a lethal cleavage. After attaching the stockings to the fittings on the basque, I speculated as to my lover's motivations in supplying these novelties to me. The incident with the porn mag on the bus floated into my mind and I swallowed my sour anger.

The change that donning this uniform made on me was total. I looked at the glistening creature in the mirror and smiled. I swayed into the bedroom and enjoyed the gasp from my boyfriend's lips so much that I decided to play with my sense of bondage-led empowerment and threw the handcuffs to the floor. "I'm never going to be like one of those girls in your magazines" I stated. Before I could explore the potential of this new outer skin, however, he was upon me like a dog; kissing, licking and priming his hips. Our vigorous sex was a little more frenzied than I had come to expect but was unaltered by the promise of discipline that my outfit had hinted at. The scenario was inspiring to me but, as yet, lacked a vital spark to make its rumour of unexplored thrills leap into fast flames.

My distraction was evident a few weeks later as I thought about my new bondage persona even as my boyfriend fucked me in lieu of a proper greeting. We dressed and went out for the usual drink at the familiar local. I was far more suspicious of any snide outbursts from him than I should have been at that point in the evening; there was still too much drinking time left before we could numb our detachment from each other with sucking, licking, fucking and screaming. I was thinking about eyeliner when his insults came in with more venom than usual. I was too drunk to pay attention to the words but the tone was clear. I remember images and impressions about my outburst now not specifics. I recall the shocked faces of the other drinkers when I screamed an obscenity in his shocked face, grabbed my glass and poured the lager over his head. I remember the gratification and arousing shock when I saw him dripping with drink and still as a statue. The surge of authority that ran up and down my arm as I placed the glass back on the bar with perfect delicacy was like a narcotic and it eased my exit from the pub. My boyfriend was left to pay for the round that he was now wearing. I came to my senses back in my lightless room behind a locked door. My anger had abated and my bladder throbbed with its heavy burden when I heard his knock. He grunted my name and ordered me to open up at once. I pushed him out of the way as I ran to the toilet with a bare moment to spare. I was smiling with contentment when

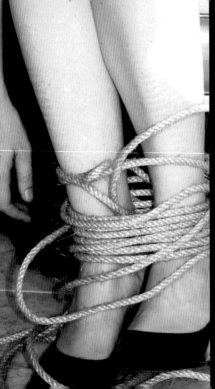

I found him in my room wearing a change of clothes and packing his things.
"I'm going back to London." He stated.

He waited for a cringing apology from me which never came.

"Go then, I'm done." I replied.

He looked at me as if he'd never heard anything quite so absurd. A twitch in his cheek signalled the eruption of burning tears from his eyes. Sadness at the futility of this relationship and exhaustion with its pendulum swings from ecstasy to depression overwhelmed me and I held his drooping body in my comforting embrace. My hard face became slick with his tears and he tried to ask me a question through his despair. He was pleading with me not to abandon him.

"I'll never leave you." I lied.

We spent the rest of the night locked in a platonic embrace like teenagers. What I craved more than anything was a tranquil weekend and the opportunity to breakup with him the following week after I had packed him off to London. He woke up from the cold night and attempted to have drowsy sex with me. I shrugged him off and explored a notion that had been with me since the previous evening. I indicated the brown paper bag and told him to take a walk while I got ready. He looked eager but distrustful in the same moment.

"Don't fret. I promise I won't lock the door when you've gone through it." I winked.

I admired my toned body in the bathroom mirror again and I was pleased; it was time to resolve my new persona with the extras I had added to the uniform in secret. The basque, stockings, handcuffs and boots were a given, of course,

send and made sure that I kept the
It amuses me still.

\>\>\> Getting stocked up
\>\>\> Toys on a budget

TOYS AND ACCESSORIES

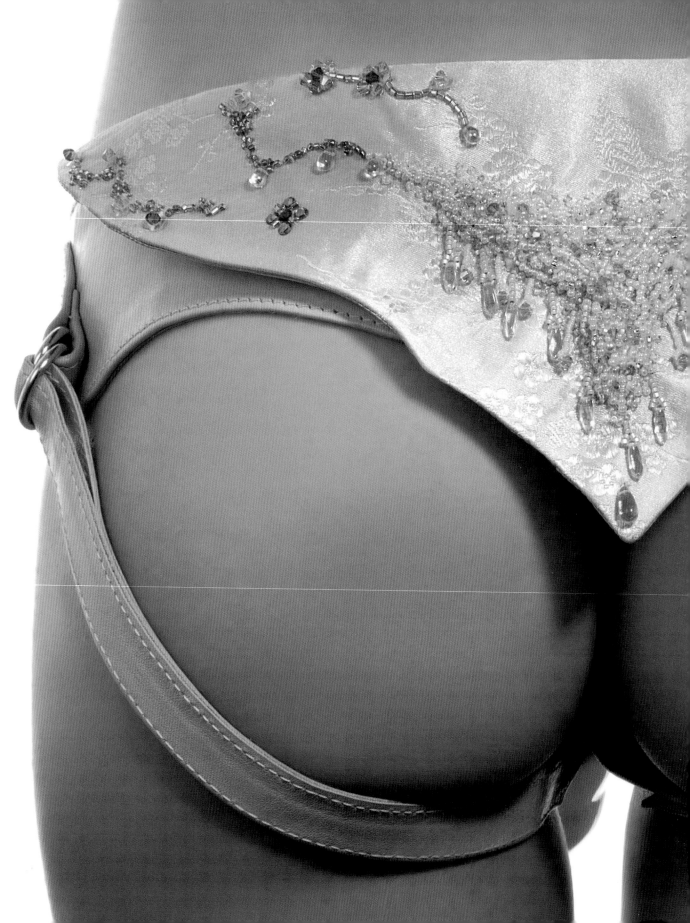

>>> Getting stocked up

You can usually find BDSM toys in sex shops as well as online. Shopping can be great fun but always remember to buy quality sex toys. It can be difficult to do a good job with poor quality toys. It might be an idea to discuss with your partner just exactly what it is you're interested in buying. You don't want to be arguing in the shop. If you're not really sure what to buy, then there are many inexpensive beginner's kits available. Such kits offer a few items to play with, including blindfolds, handcuffs, maybe a nice soft whip and sometimes nipple clamps. If you're intrigued by bondage, then there are many arm and leg restraints made from black leather as well as Velcro. Restraints combined with a blindfold promise extra excitement. This way the submissive partner has no idea of where you are or what you are going to do.

Bondage tape is an inexpensive and easy way to restrain your partner. It is just as effective as rope or leather restraints, but safer and can even be used as a gag: silence is golden!

Every good dominant has a choice of whips and paddles. Spanking with a paddle increases the sensitivity of the skin, which leads to heightened intensity and pleasure. Start slowly and be gentle.

If you're intrigued by nipple clamps then first timers should go for adjustable clamps. Clothes pegs can also be effective, but be careful when removing then when the blood rushes back to the nipple.

There are also furniture pieces and harnesses which offer even more restriction of movement for the submissive partner. Collars are often used in BDSM play and you could lead your partner around by their leash and collar before punishing them.

Once you've decided on a toy or toys, then get ready to take your partner on an unforgettable journey of heightened pleasure. Remember it's all about having fun!

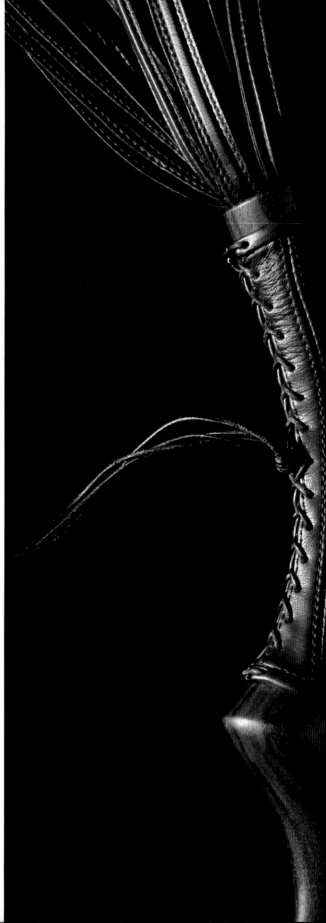

Here are some of our favorite toys:

Whipcraft
www.whipcraft.com
Danish artist Troles Jespersen has over 25 years experience in the art of whip making. He developed the ultimate whip, which was presented in the erotic fair Kinky Copenhagen in 2003. His designs include colorful whips which are completely ergonomic as well as elegant. The whips are handmade and include a variety of materials from leather to latex or wood.

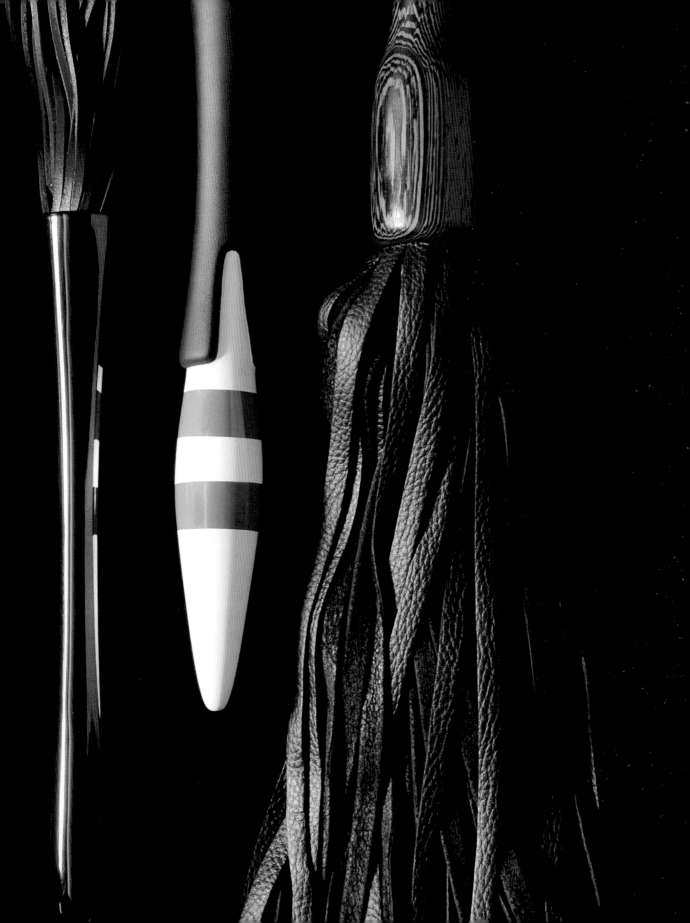

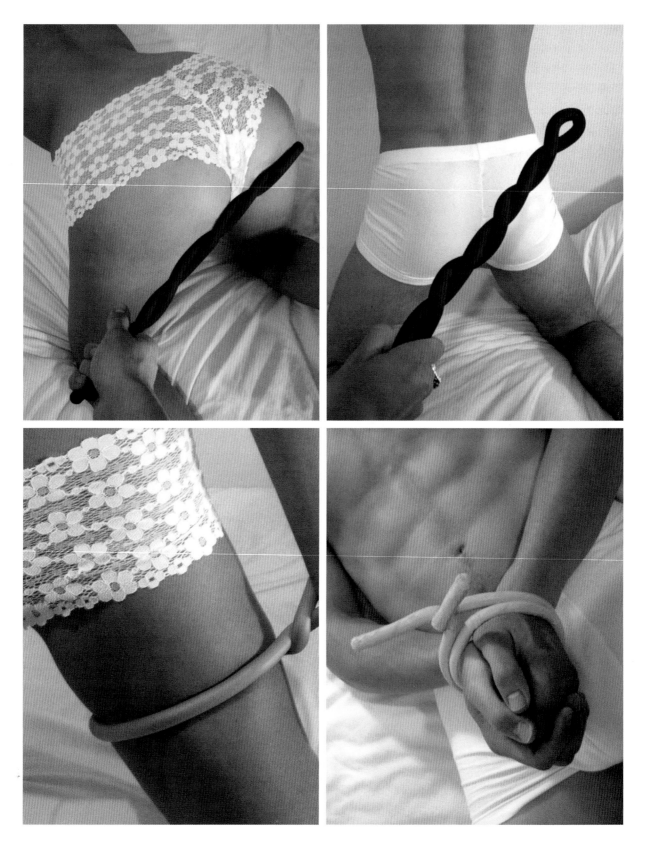

Friendly S&M...

Spank Ties
www.spankties.com
Spank Ties are fantastic for beginners, offering the possibility to spank and tie up in one toy. They can be used in three ways: tying the wrist to the thighs, tying the wrists together, or as a spanking implement.
With Spank Ties you don't have to worry about causing your sub any pain as they are reported to sting without actually hurting. When used as a restraint, you don't have to worry about losing the keys!

Shiri Zinn

www.shirizinn.com

Shiri Zinn is a conceptual designer who makes high quality glamorous sex toys. Her creations represent a fusion of art, jewelry, fashion accessories and product design. The materials used include glass, feathers and diamonds. Solid organic glass is the latest material to be used in sex toy manufacture. It allows for a more weighty feeling and is a wonderfully receptive material to warm and cold sensations. Feather is a profoundly sensual material. All silver used is hallmarked and made by Formula One trophy makers.

The Swarovski crystals used are set by Debeers trophy award setters. Each piece is stamped with a limited edition number and engraved with the artist's signature.

Bijoux Indiscrets

www.bijouxindiscrets.com

Bijoux Indiscrets specialises in sensual cosmetics and erotic products. All the pieces are presented with impeccable packaging. It can really seem like you're receiving an exclusive present, jewelry or perfume. Bijoux Indiscrets offers an exciting range of sensual products including sweets for oral sex, ticklers, scented petals, music, feathers, games, scented candles, blindfolds, incense, massage oil, and handcuffs. A special feature are the coffrets, designed with special occasions or erotic games in mind.

Bijoux Indiscrets offers a fantastic pair of ribbons for tying up with this book. Perfect for beginners!

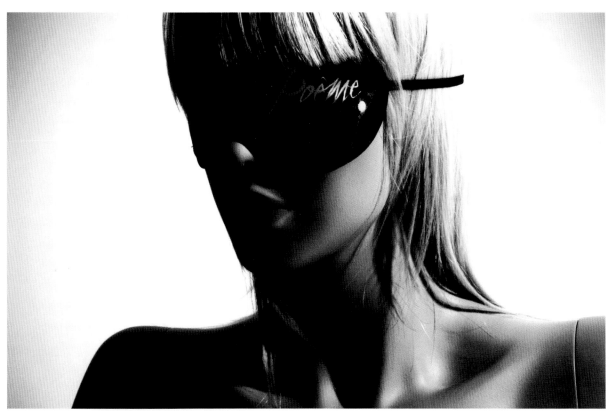

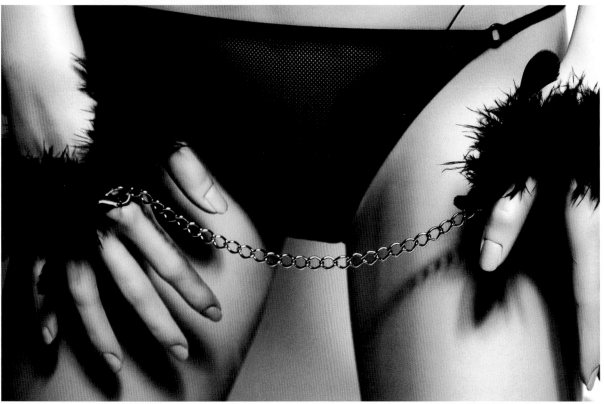

Fleet Ilya

www.fleetilya.com

Fleet Ilya is an accessories label based in London founded by Ilya Fleet. The creations combine leather and great imagination. Ilya Fleet's pieces range from corsets to masks and headpieces. Of particular note is the luxury restraint line, which features wrist cuffs, ankle cuffs, harnesses and collars.

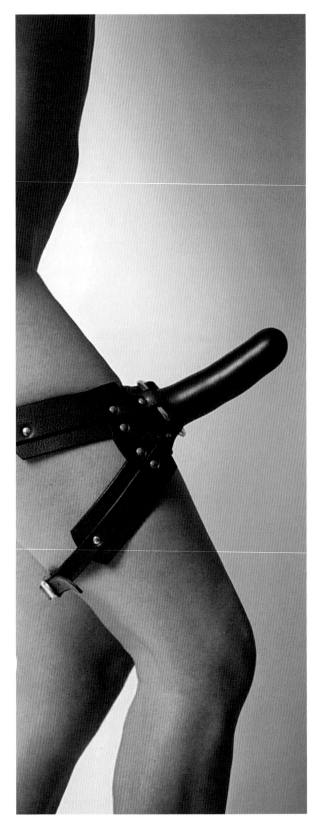

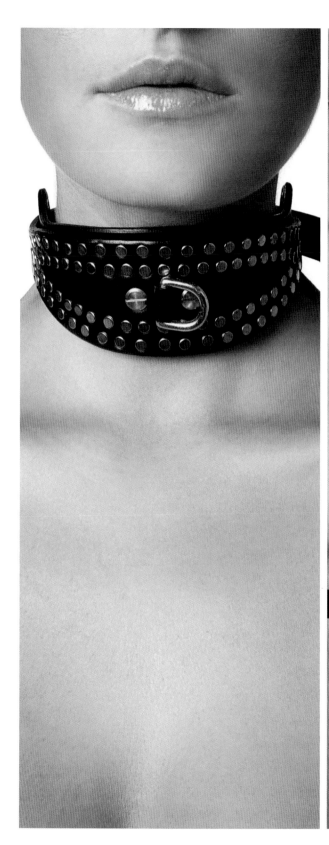
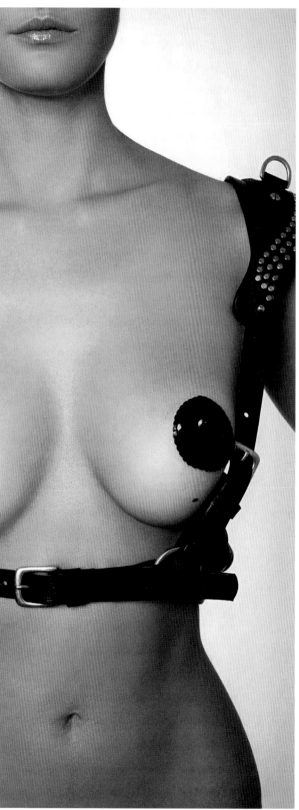

51

Paul Seville

www.paulseville.co.uk

Paul Seville offers a wonderful collection of handmade leather fashion accessories including figure hugging waist wraps and corsets, delicate twisted and moulded leather belts and jewelry embellished with "knotted" antique chain and ribbon. The Boudoir collection features masks, vanity paddles, whips, and feather ticklers.

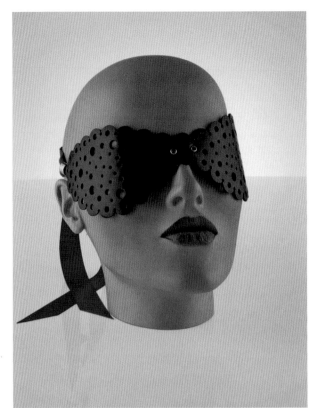

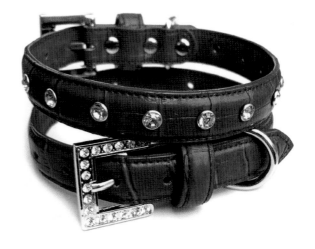

>>> Toys on a budget

There are many cheaper alternatives to all the before mentioned toys and accessories.
Try using things that you already have around the house.

Toy	Cheaper alternative
Blindfolds	Stockings, scarves
Canes	Rulers
Whips	Leather belts
Collars and leads	Dog collars from pet shops, dog leads, ties, scarves
Bondage rope	Normal rope from hardware store
Handcuffs and anklecuffs	Belts, stockings, industrial tape
Gags	Belt tied to mouth, silk scarf tied, industrial tape
Nipple clamps	Clothes pegs
Hoods	Balaclava

>>> Dressing up for BDSM play
>>> Get the look
>>> Hoods and masks
>>> Boots and shoes

DRESSING UP

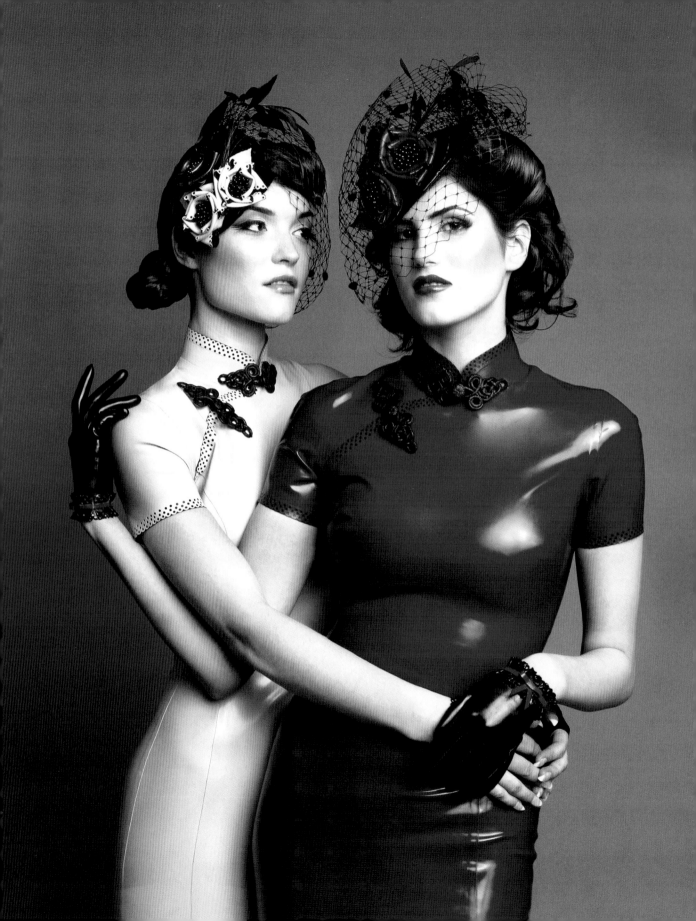

>>> Dressing up for BDSM play

How you dress often changes people's attitude towards you. It can also reflect how you're feeling inside, or what attitude you want to transmit. Dressing up for BDSM play can help you to be more convinced of your role. Fetishwear tends to be black, although there are more and more garments available in different colors. Fetishwear stimulates all the senses and creates an alluring sight for all. People are attracted to leather and latex for many reasons. It could be the smell, or the feel of it on the skin as well as how it looks. Leather also implies dominance. Female dominants tend to wear latex catsuits or corsets, accentuating their bodies without showing too much. However, it isn't uncommon for her to wear a corset that exposes part of her body, to cruelly emphasise the untouchable. Male dominants usually wear black, more practical clothes. Female submissives tend to wear very little. It could be just a neck collar, a corset or some extremely high heels. Corsets that enhance an hourglass figure are also favored by female dominants. Both male and female submissives sometimes wear a harness made of rope or leather. It exposes the submissive, yet they are dressed in some way, giving the dominant some extra places to attach a lead.

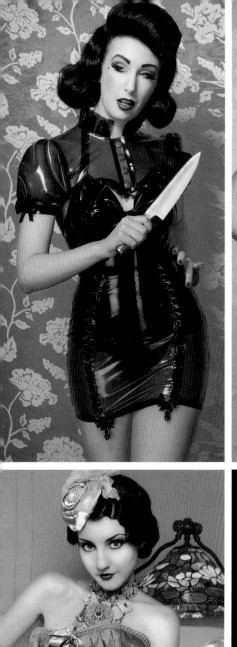
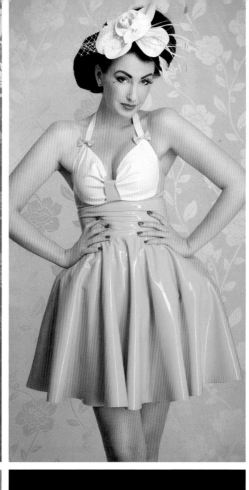
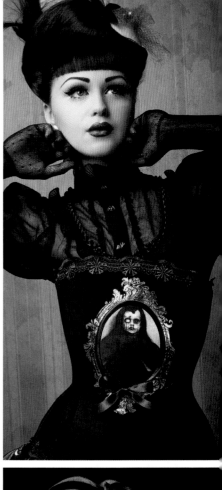
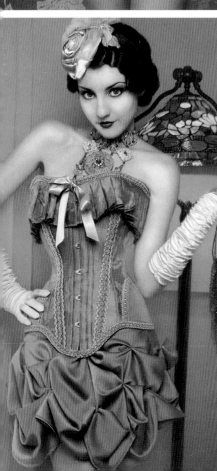
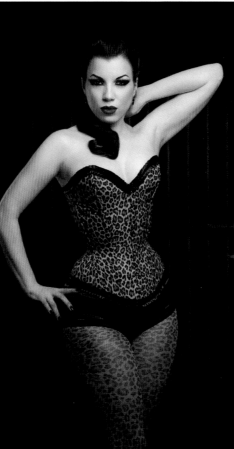
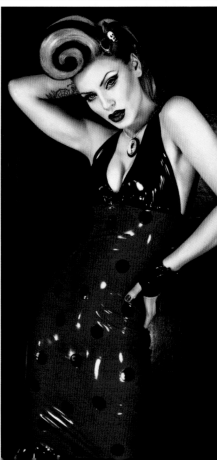

Latex

Latex is a popular material for fetishwear. The feel of latex doesn't block any pain like normal clothing would, but can leave a submissive feeling very vulnerable as it tends to be skin-tight, producing a "second skin" effect. Latex fetishism is the attraction to people wearing latex clothing or, in some cases, to the garments themselves. It can be tricky to put latex clothes on due to friction against the skin. Many latex fetishists use talcum powder.

Skin Two *is a leading fetish magazine for latex lovers.*
www.skintwo.com

Rubber

Rubber tends to be thicker and more matte than latex.

PVC

PVC (plastic polyvinyl chloride) is a lot cheaper than latex, but obviously doesn't look as good!

>>> Get the look

Très Bonjour

www.tresbonjour.de

Très Bonjour based in Berlin, Germany, is a latex lingerie company that promises a couture feast for the senses. The collection includes bikini strings, triangle bras and suspenders, as well as underwire-bras, torselettes and panties. Très Bonjour also offers many accessories such as garters, short gloves and playful futuristic stockings and collars to complete each seductive outfit.

Naucler Design

www.nauclerdesign.se

Naucler Design is a latex fashion clothing and accessory company located in Umeå, Sweden. Their objective is to provide the modern woman with high quality latex fashion at competitive prices. They also aim to integrate latex in the mainstream fashion industry by enabling new possibilities for the latex fabric and couture.

Bibian Blue

www.bibianblue.com

Bibian Blue is a corset designer from Barcelona who opened her showroom in 2001. Her designs have featured in many alternative fashion shows in London, Paris and Barcelona. Bibian Blue's collection is diverse, ranging from elegant and classic corsets to elaborate, anticonformist clothing; always striving to enhance the female figure. Her current collection combines elaborate and feminine colours suitable for many different ages and styles.

Lady Lucie

www.ladylucie.com

Lady Lucie is a London-based latex fashion designer, costumier and couture corset-maker. She creates unique, contemporary outfits using only the finest luxury materials – latex, silk, satin,

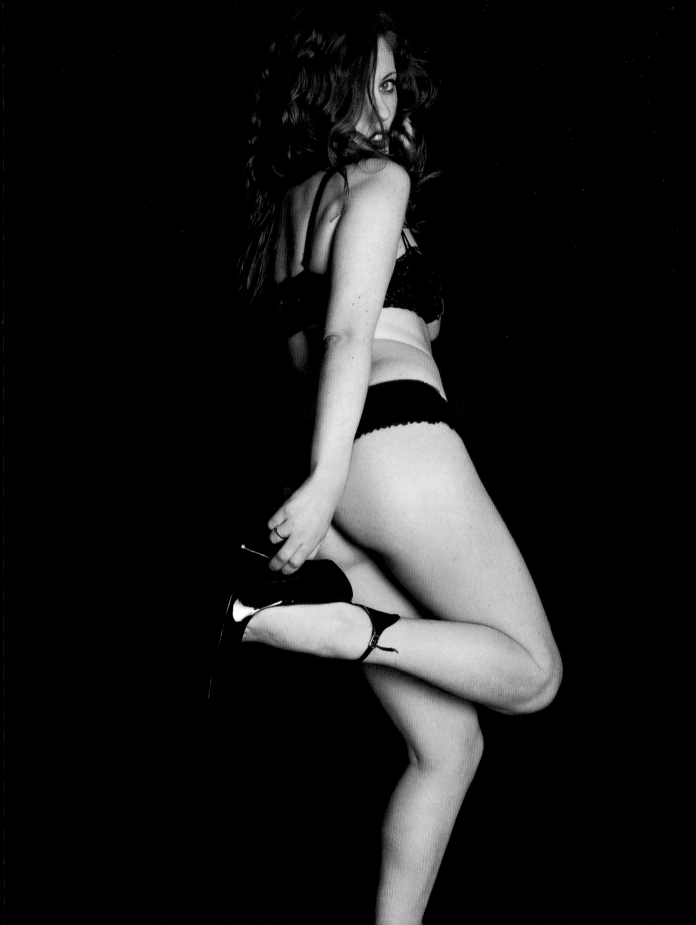

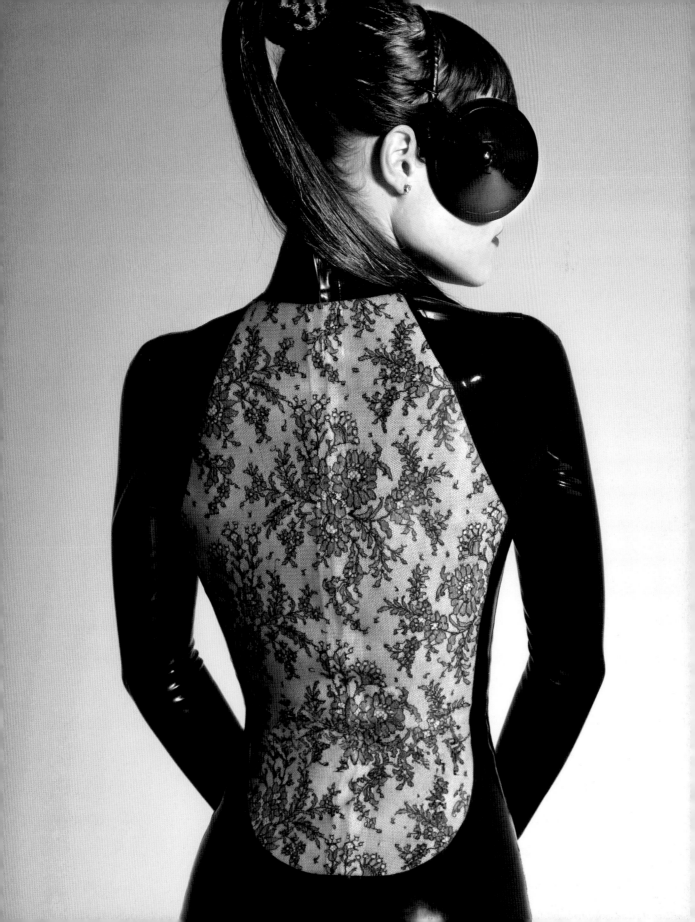

lace and leather – combined with advanced pattern cutting techniques and traditional couture processes. Every garment is handmade to create something beautiful, durable, classically stylish and fun. The collection includes tops, dresses, lingerie, accessories and catsuits.

Petra Dos Santos

www.petradossantos.de
Petra Dos Santos is a leather clothing designer based in Berlin, Germany. Petra specialises in masks, neck corsets, harnesses and just about anything a demanding fetishist would want.

Atsuko Kudo

www.atsukokudo.com
Atsuko Kudo produces latex outfits, which have recently increased in popularity thanks to having clients like Lady Gaga. The collection includes impossible gloves, eye patches, and pin-up dresses, all in a wide range of colours.

>>> Hoods and masks

Gumena

www.gumena.com
Gumena offers a collection of unique luxurious rubber masks and hoods.

Demask

www.demask.com
Demask is a fetishwear company that opened in Amsterdam in 1990. They offer unique designs of latex and leather as well as an extensive range of rubber masks. The masks include cat-masks, gasmasks, hoods and gags.

>>> Boots and shoes

Footwear is important if you want to get the right look. Latex or leather boots are popular amongst BDSM lovers. With female dominant situations, boot or shoe worship is a popular fetish game, having the submissive male worship boots. The heels should be high enough to accentuate the dominant's figure and give her a bit of extra attitude. They should not be too high to walk in.

Extra high heels are often worn by submissive females and can be torturous to walk in. Walking like Bambi can make any woman feel vulnerable, although they do make the legs look very attractive!

Ainsley-T

www.ainsley-t.com
Ainsley-T, based in Milan, offers a sexy and beautiful range of innovative footwear, using the highest standards and top quality materials that are synonymous with Italian design. At first glance, they look like another collection of sexy heels, but if you look closer you will see that many of the heels can also be used as butt plugs, and there are even some with ball-gags straps.

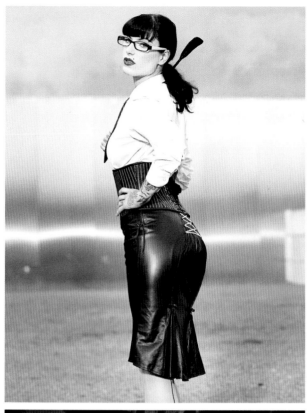

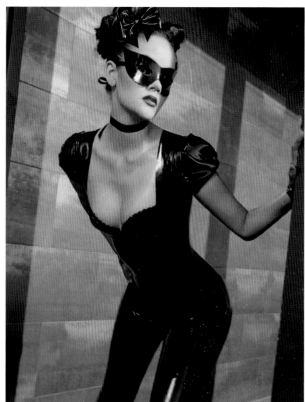

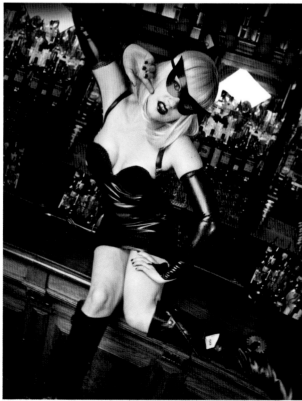

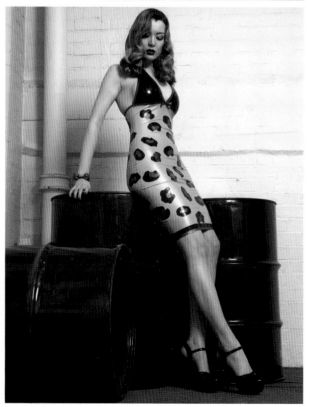

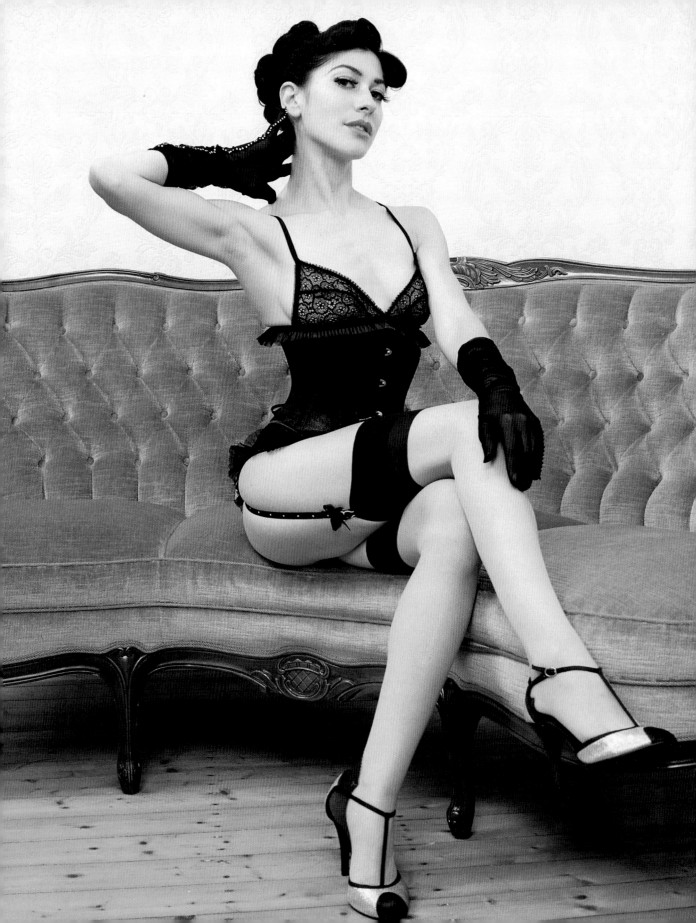

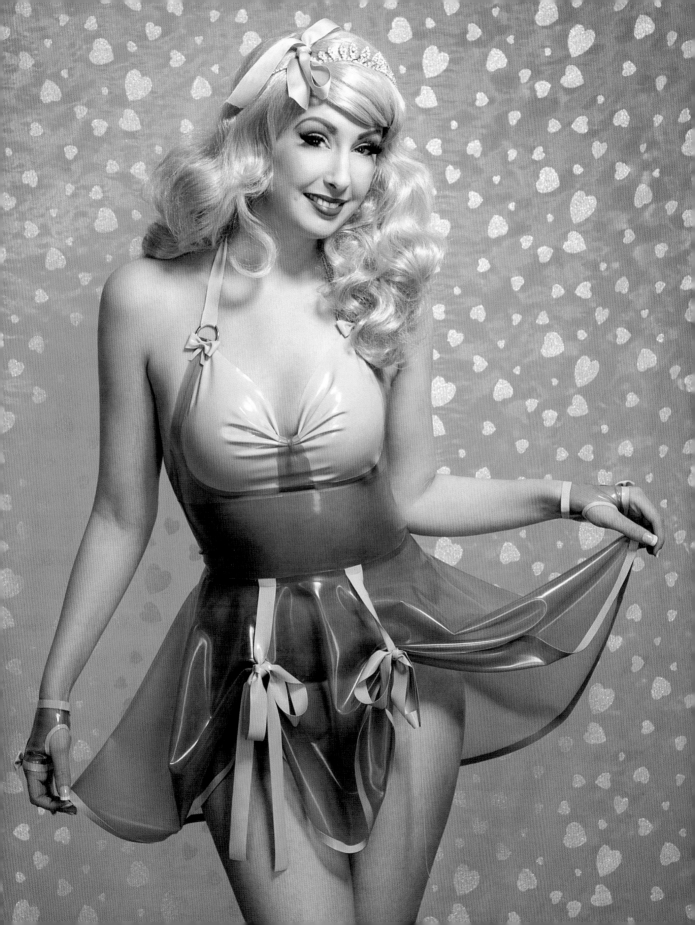

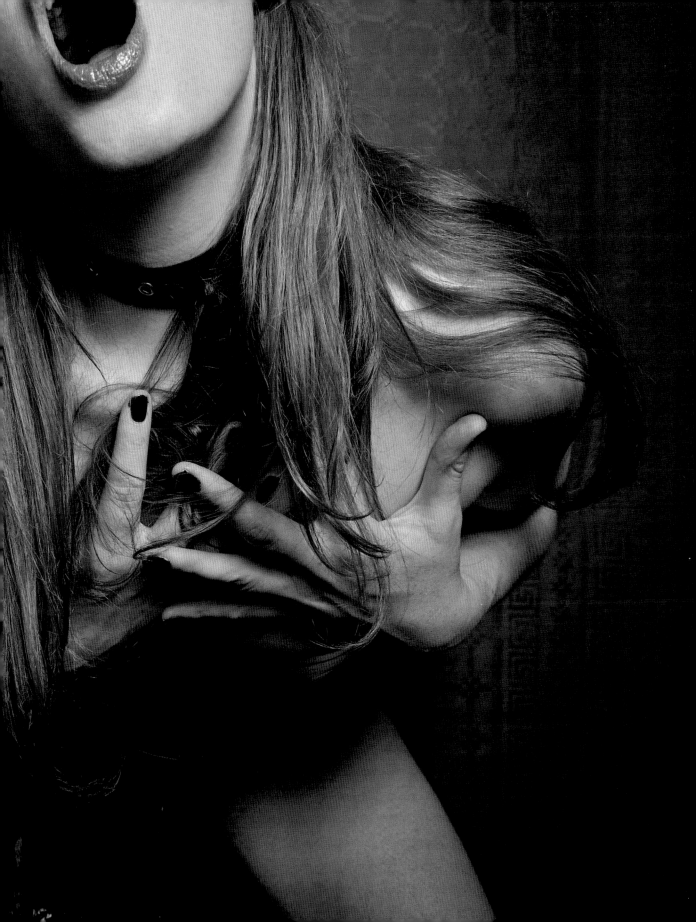

>>> Welcome to the dungeon!

WELCOME TO THE DUNGEON!

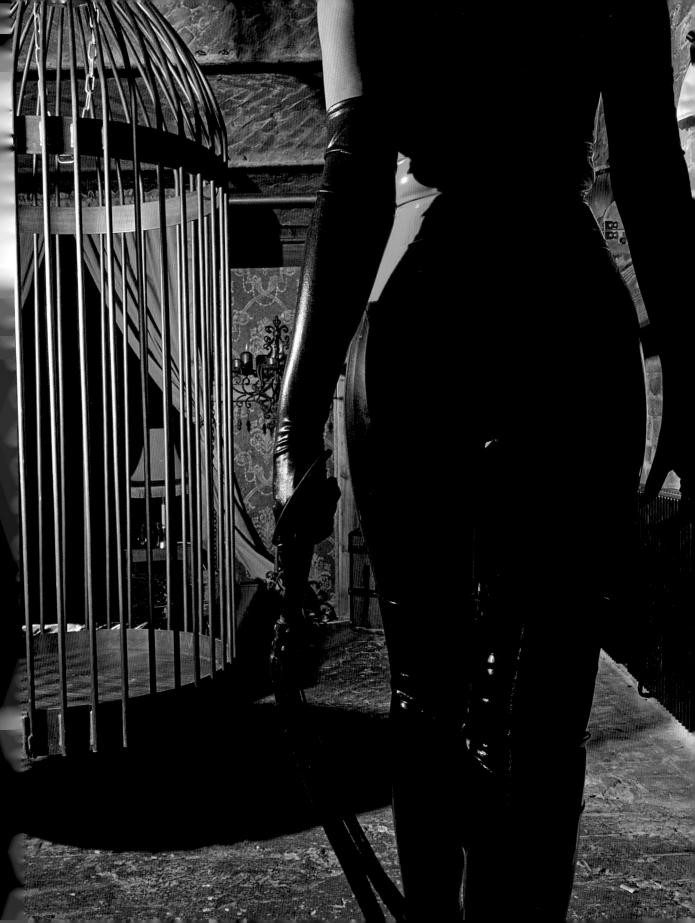

>>> Welcome to the dungeon!

In the past dungeons were underground prisons typically built underneath castles used for torture. In the world of BDSM, a dungeon is a room that is equipped for playtime.

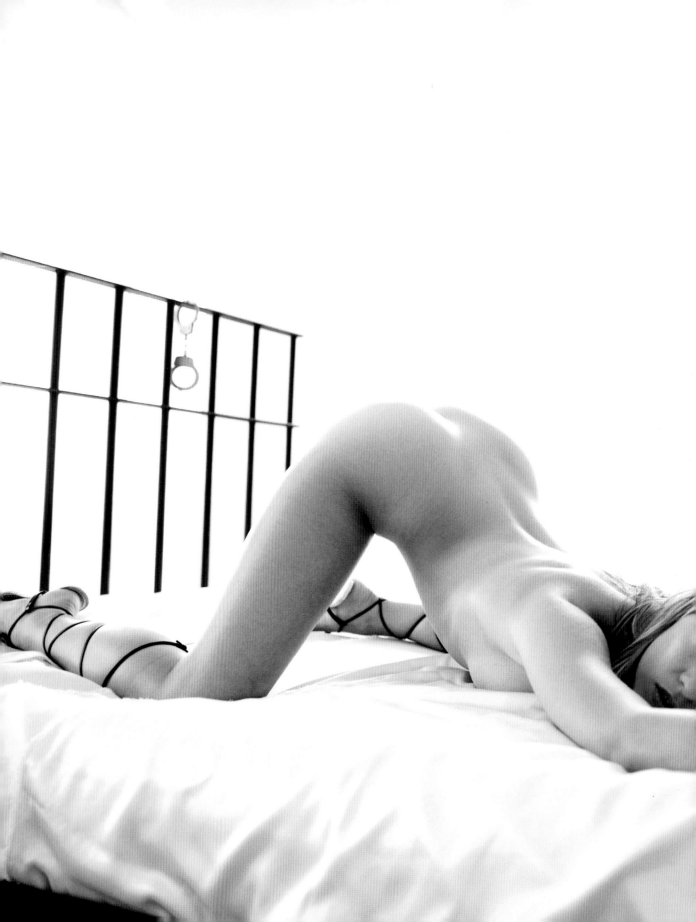

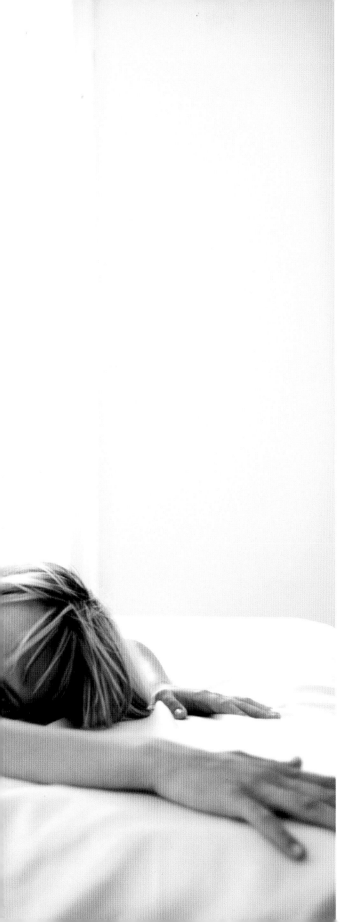

Jailhousefuck

www.jailhousefuck.de

Jailhousefuck is a German company who make solid steel beds. They come in five parts, and both the headboard and footboard are available in different heights and widths. The beds are delivered worldwide and even come with a pair of Smith and Wesson handcuffs with two keys. You'll never want to get out of bed – or may not be able to!

Dungeon Furniture

www.dungeonfurniture.com

Sonny Black's Dungeon Furniture is based in Los Angeles, USA. The collection features cages, bondage beds, bondage tables, spanking benches, crosses, and worship thrones. Sonny Black's pieces are favored by many photographers, film makers, professional dominatrices as well as many couples who practice BDSM.

The Stockroom

www.stockroom.com
www.stockroom.com/gear/bdsm_furniture

The Stockroom is a fetish company based in Los Angeles, USA. They have a wide range of sex toys, restraints and dungeon furniture. Their dungeon furniture collection includes beds, cages, swings, and sex machines. The Stockroom has a fantastic showroom that all fetishists could easily fall in love with.

Fetters

www.fetters.co.uk

Since its creation in 1976, Fetters has become a name that serious bondage enthusiasts trust. In their collection of bondage furniture, you can find bondage headboards, worship seats, spanking horses, cages, whipping benches, crosses as well as a revolving wheel.

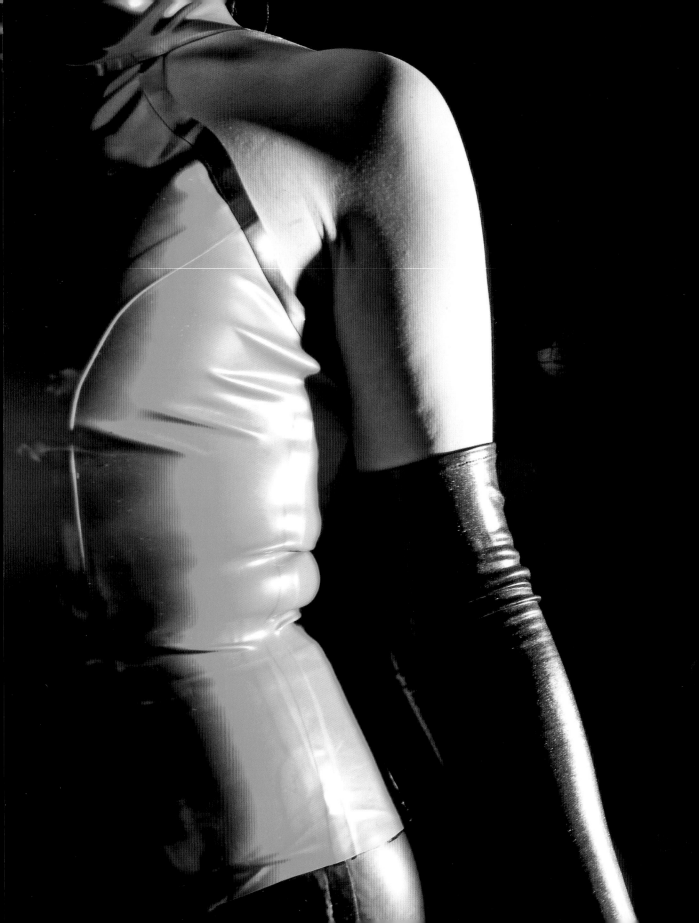

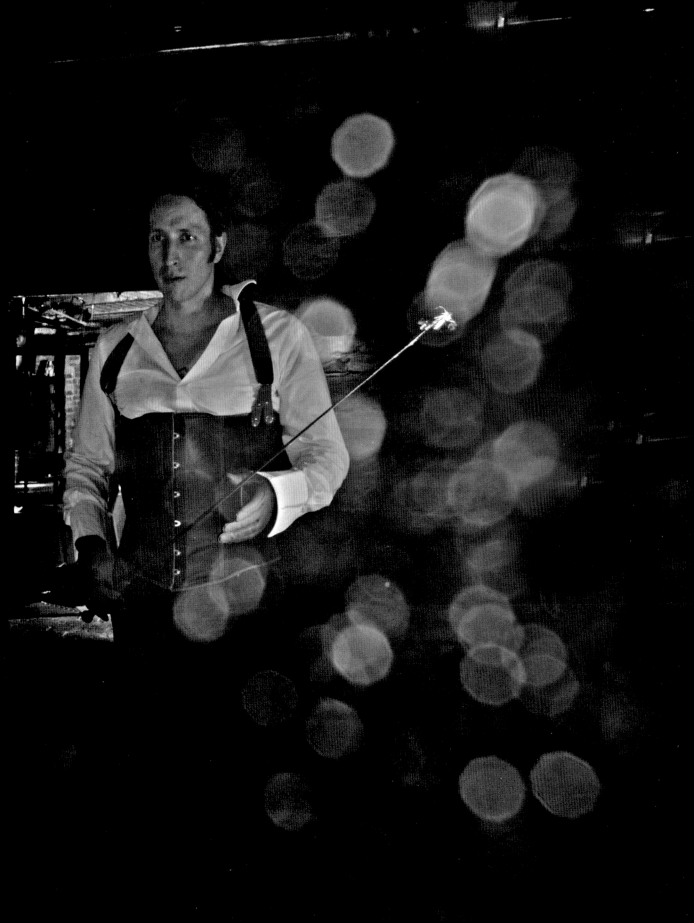

ROLE PLAY

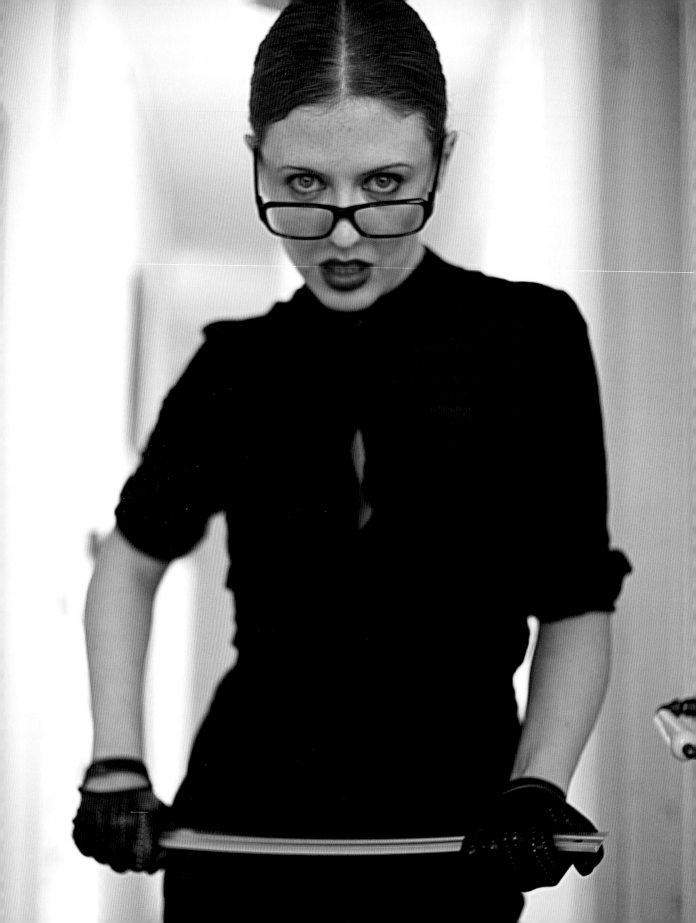

>>> ### >>> What is role play?

Role play is a game that usually involves a dominant and a sub-missive role. Role play can give you the freedom to do or say things that you never would in your normal persona. You may discover alter-egos that you never knew existed. It can also kill the monotony of being with the same person night after night. Often people who are dominant in their day-to-day life like to take on submissive roles in a role-play situation and vice-versa. Many men who visit a dominatrix are in fact professionals with a lot of responsibility. They have so many people counting on them, they long to let someone else think for them even if it is for just a little while. Not being in charge for a change can be such a relief. The same is true for shy, submissive types. Often people who are not assertive in their daily lives, or even in their relationships, find a whole sensation of liberation when playing a dominant role. It gives them the voice they lack in their day to day. "Switch" refers to people who are equally capable of play-ing both dominant and submissive roles.

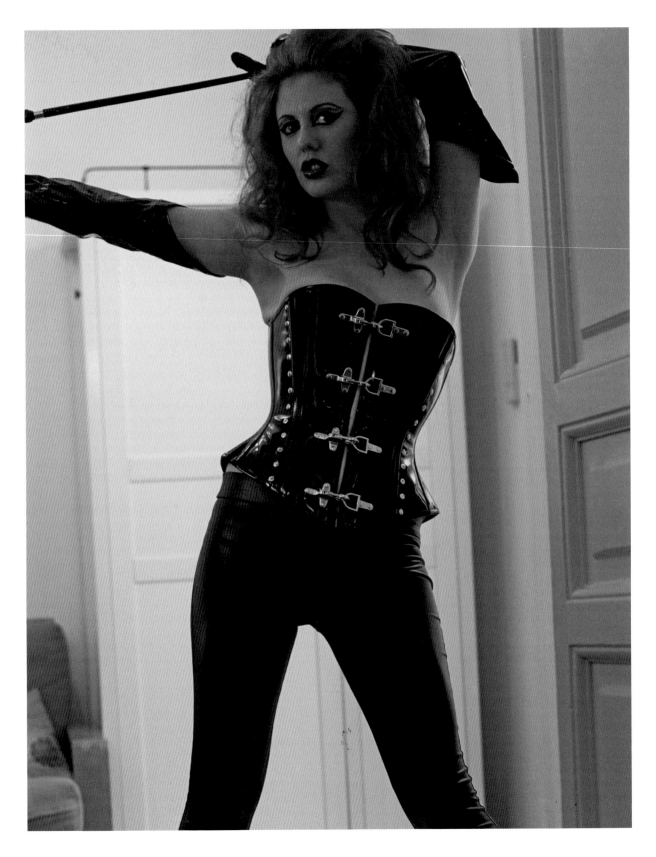

>>> Getting started

If you're new to role-playing, then it may be wise to just take a moment to assess what kind of character yo have in your normal life and compare it to the kind of role that excites you in a role-play scenario. Are you bossy? Are you shy? Or are you a bit of both? Who is "the boss" in your relationship? Who is the boss in the bedroom?

What are you? Sub, dom or switch?
Question 1
Your boyfriend asks you to make him a cup of coffee. You...
A: Ask him if he wants anything else from the kitchen.
B: Ask him if he's joking and order him to make YOU a coffee.
C: Say okay, but next time he has to make one for you.

Question 2
How would you react if your partner ordered for you in a restaurant?
A: Say nothing, but think "what a gentleman."
B: Interrupt him. Who does he think he is?
C: Say nothing but make sure you order the desserts.

Question 3
How often do you initiate sex?
A: Rarely/Never.
B: Most of the time.
C: Sometimes.

Question 4
You're out with your boyfriend and he bumps into a work colleague. They started talking about work stuff that you know nothing about. There is no eye contact and you may as well be a piece of furniture. You...
A: Say nothing and hope this boring conversation ends soon.
B: Interrupt the conversation. How dare he not include you!
C: Give him the benefit of the doubt, just because it was a work colleague and maybe it was important, but let him know after never to treat you like a decoration.

Question 5
It's your anniversary and your partner has agreed to a quiet romantic night in with candlelit dinner and a bath. There is an "important" sports event that same evening and your partner asks if he can just see the highlights on the TV. You...
A: Let him. After all, it's just the highlights and he has been so good sacrificing the rest of the game.
B: Put a blindfold on your boyfriend and turn the TV on with the volume down and explain to him what's happening in the most ignorant generalised way you possibly can. How dare he even think about sport!
C: Let him for just five minutes while you slip into some new lingerie to surprise him.

Question 6
You're organising a holiday with your boyfriend. He offers to take care of things, i.e., organising the flights and the hotel. You...
A: Trust him completely. He knows best.
B: Make sure he pays, but YOU decide which flights and hotel to book.
C: Enjoy being taken care of and organise a surprise for him whilst you're there.

Results

Mostly As: submissive
You like letting others decide for you. Maybe it's time to try a dominant role to express your hidden desires.

Mostly Bs: dominant
You like to be in control at all times. Maybe you might like to take a break from bossing people around all the time... Try submissive roles in role-play to discover a new you.

Mix of As, Bs and Cs: switch

Mostly Cs: switch
You like to be in control but you don't feel threatened if someone else makes decisions for you from time to time. You can probably adapt to both dominant and submissive roles easily.

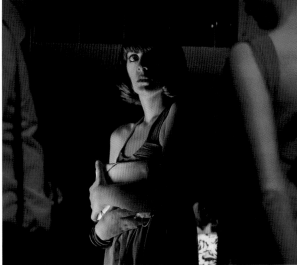

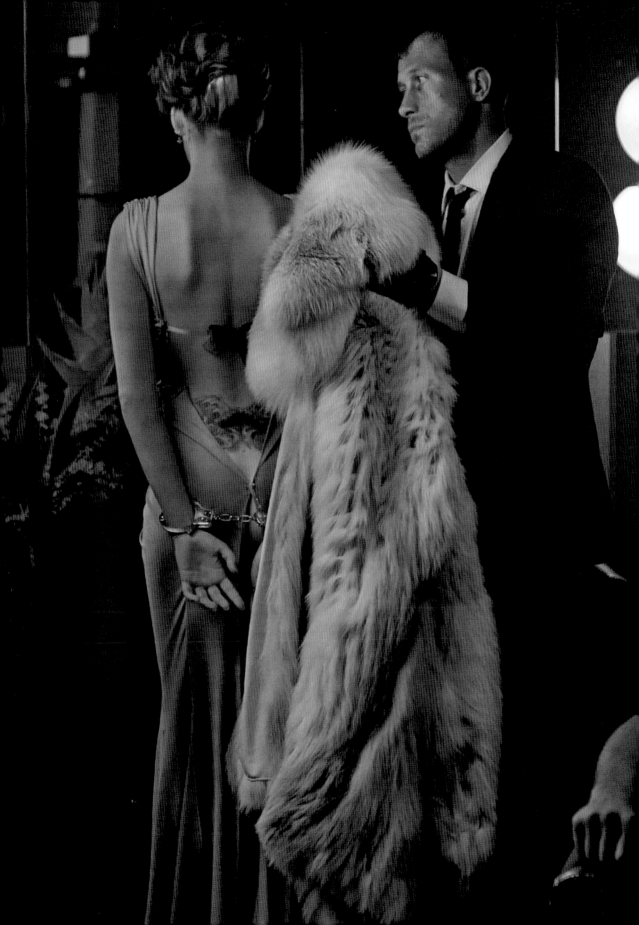

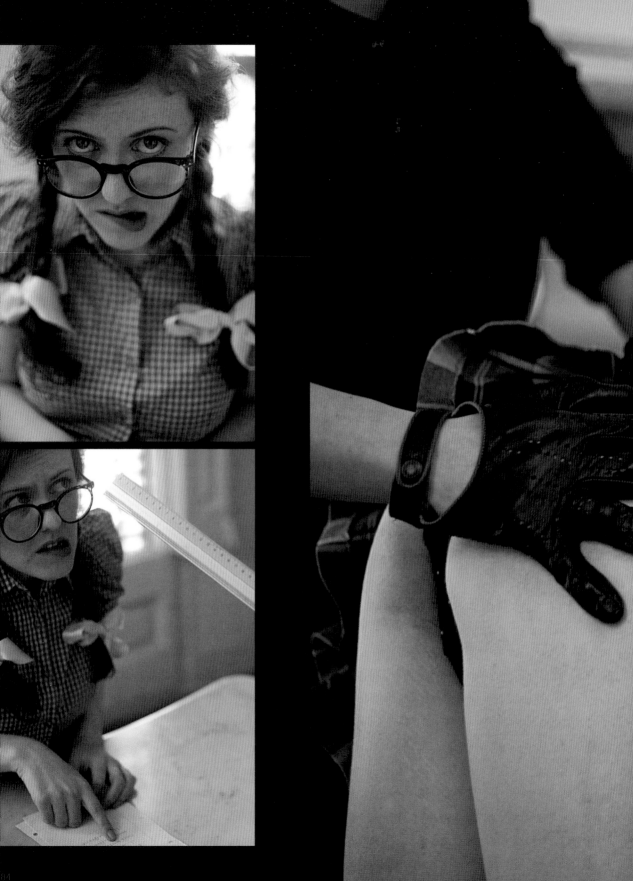

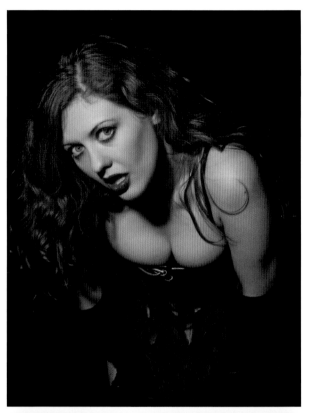

>>> Role-play scenarios: private

In most role-play situations, the objective is to get it on. However, role playing presents numerous obstacles, which can be thrilling. The obstacles in that journey are placed by both participants and can often feel like a test of wit, quick thinking and desire...

Teacher and student
You may need: long ruler, text books, notebooks, red pens, school uniform, long white socks, pigtails...
One of the most classic role plays. Speaks for itself really – discipline from the teacher, and provocation and general misbehaviour from the student. It might be a good idea if the teacher "plans" a very simple class. If not, the teacher could be giving a detention to the pupil, after being caught misbehaving. The teacher decides the punishment and the pupil decides to collaborate or not. You could do the classic Lolita-inspired schoolgirl and male teacher. However, you could also have the female as the strict teacher with a submissive naughty teenage boy. We all know what teenage boys get up to!

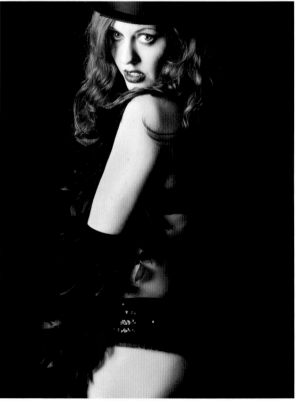

Doctor and patient
You may need: nurse's uniform, white overcoat, white latex gloves, medical kit...
Possible scenarios could include a general check-up, where the patient decides on the symptoms. The doctor could possibly take advantage of the ignorant submissive patient. The doctor or nurse could also give a shocking diagnosis with a "miracle cure." The patient just has to want to get better!

Master/mistress and dog
You may need: dog collar and lead, dog bowl, bone...
This is an extremely popular role-play, and don't forget that the props can be bought from pet shops which are much cheaper than in specialist fetish shops. Make the dog lick, bark and eat from a bowl on the floor.

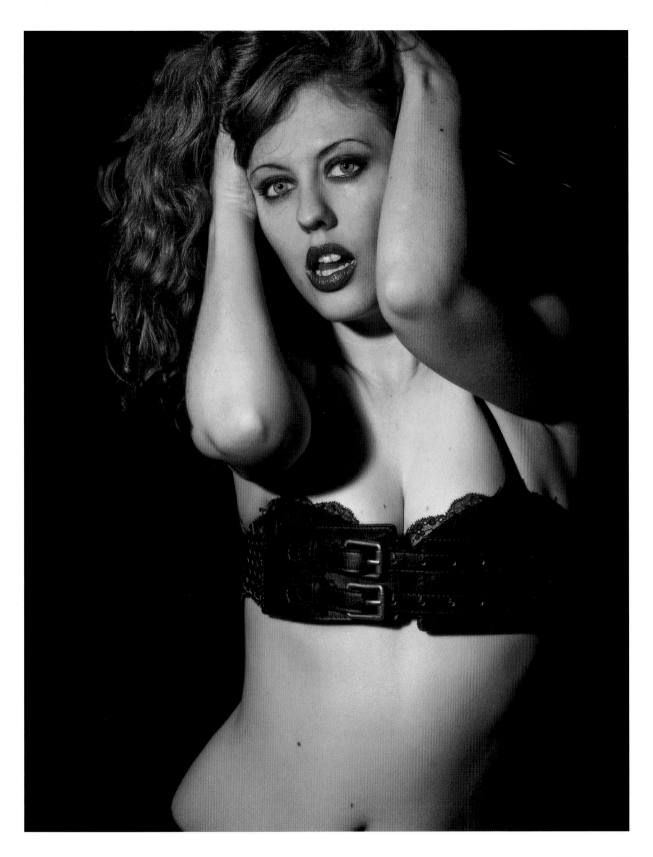

Mistress and cleaning boy/master and maid

You may need: apron, duster, various cleaning utensils.

Who is the messy one in your relationship? This role-play probably works best when the messier one from the couple is forced to clean. There are of course punishments for "missing a bit" as well as rewards for good cleaning. The cleaning boy or maid should be naked apart from an apron and readily available to be fondled. The master or mistress can either keep a watchful eye on the cleaning or just sit back, relax and give orders. For an extra twist, make the cleaner scrub the floor on all fours. You could make the cleaner hand-wash the dishes even if you have a dishwasher. Use the most traditional and difficult methods available.

Football slave

You will definitely need: beer and a football match.

Isn't it annoying how much men love football? If you're feeling like being especially submissive, why not offer to be his slave while he watches the footy? Football slave tasks would include bringing him cold cans of beer from the kitchen and being available to give him oral sex while he drinks his beer and shouts "goal!"

WARNING!: this role-play should only be used on very, very special occasions and only if your boyfriend has done something special to deserve it. We do not recommend that any man gets used to this, and you shouldn't let him either!

Burglar

You may need: balaclava, bin bag.

Imagine you're enjoying a relaxing night alone at home. You could be just watching the TV, relaxing in a hot bath, or just pottering around the house. Suddenly in comes a burglar with a big bin bag and a balaclava. You must threaten to call the police and the burglar will either become more threatening or get scared. This role-play gives the possibility of either role being the dominant one.

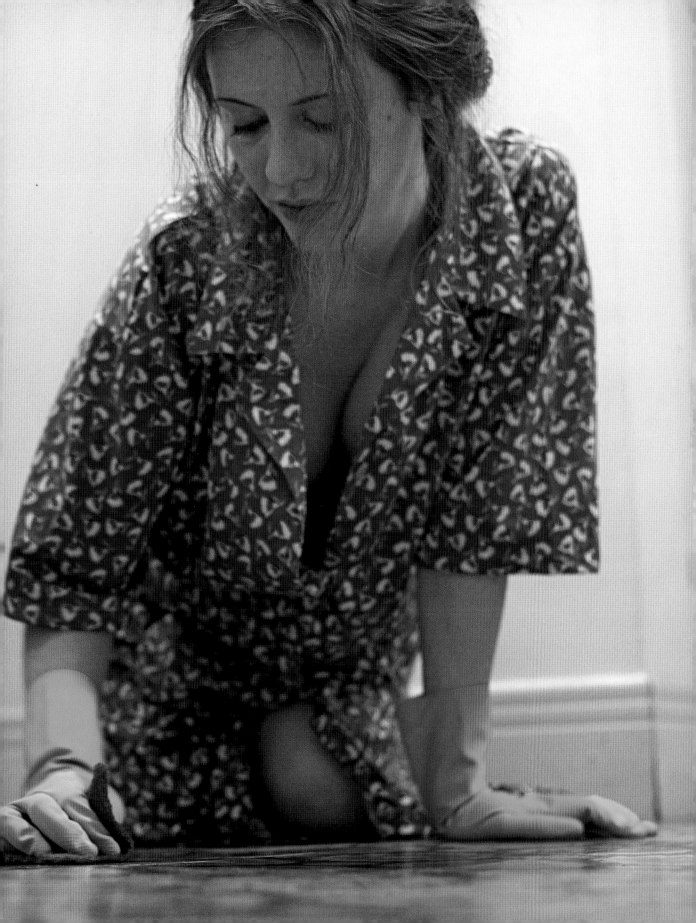

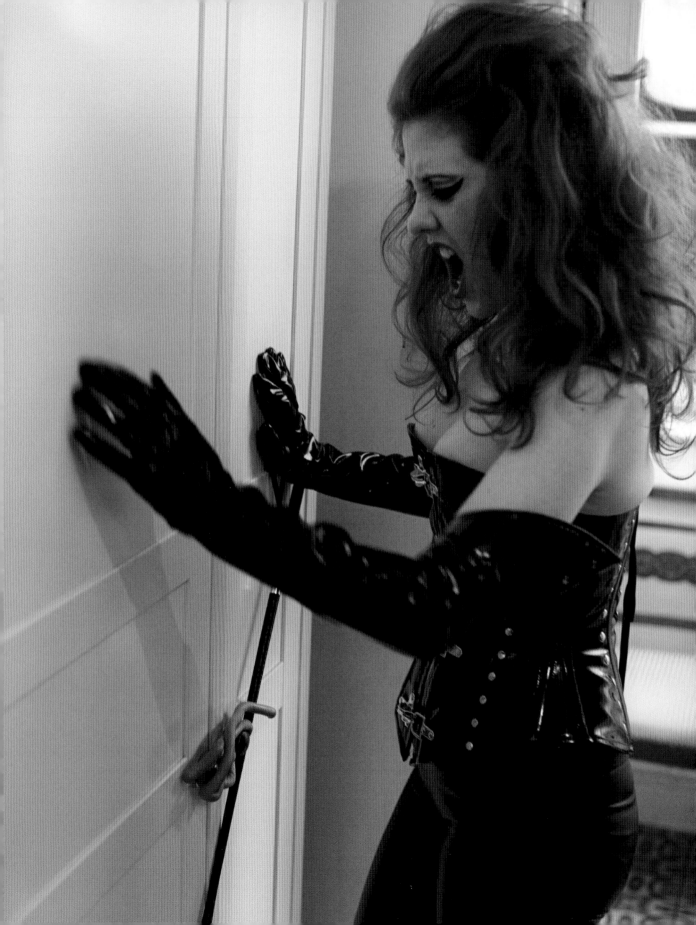

Confession: priest and sinner

You may need: bible, a guilty mind, some sins...

For those of you who are not familiar with the confession ritual, it basically consists of "Bless me, father, for I have sinned..." Then you tell the priest all your sins and he then gives you a "penance" that consists of prayers or good deeds. Confession is a fetish in itself. Imagine a traditional confessional. What do you think the priest is thinking hearing all those sins? There are even fetishists who install confessionals at home. The Catholic Church gives its sinners the opportunity to confess their sins. Just confess and you'll feel so much better. Get rid of that guilt. But what if your sins are so bad that not even your local parish priest will forgive them?

Prostitute and client

You may need: money, kinky underwear, provocative clothes, scary make-up...

If you pay for it, then you usually get what you want. You can either be a call girl for your partner, or he can be a struggling gigolo. First establish your category. Are you a streetwalker or a luxury escort? Or are *you* paying for it? Just how old and desperate are you? This role-play has a number of possibilities and can be done in public or in the privacy of your own home. The client decides what service is required and the prostitute must work hard to earn the cash.

Job interview

You may need: a job ad, a curriculum vitae...

Prior to the interview, it's a good idea to decide on the job vacancy in question. The interviewer must ask the most trying questions and check out the candidate's motives for the position. How much does the interviewee want that job? Bribery is a must. To give an extra twist it might be an idea to tell the candidate at the end the position they have just been interviewed for is no longer available.

Master/mistress and slave

You may need: collar, black leather clothes, a whip or a paddle. Some couples use the idea of BDSM slavery as a lifestyle arrangement. When it's a role-play, you need to first decide if it's master and slave or mistress and slave. Once you've decided, the owner must order the slave to do whatever he/she wants and the slave either cooperates or is punished for disobedience.

>>> Role-play scenarios: public

Pretending you've just met

This is a great way to spice up a monotonous relationship. Many couples love to remember how they met and the first date, first sex and the honeymoon period in general. Unfortunately, day-to-day realities force couples to lose touch with the magic that initially brought them together. So, why not pretend it's the beginning all over again? A great way to do this would be to go to a bar but imagine that you are strangers. The girl could sit at the bar alone and her partner can watch from a distance and when some potential rivals try to chat her up, hopefully he should remember just how lucky he is. After a time when the body language of both is that of strangers, it might be time for the guy to make his attack. The girl should not be interested at first and the guy must try hard to impress.

Lost tourist

Imagine dressing as a typical tourist with bum-bag, camera hanging around your neck and holding an open map. When you spot your partner, approach him and ask him for directions. Hopefully he will realise that you don't know where you are and that you don't know the city and want to take advantage of your naivety. This is a good one to do if you're on holiday together.

Lawyer and criminal

Imagine meeting in a busy bar or café during the daytime and imagine that it's a first meeting between a lawyer and a criminal of a perverse crime, who needs legal representation. The lawyer must of course be intensely disgusted by the "crime" and try to humiliate the "criminal." The more people around to overhear, the better and the more exciting it will be.

Hotel affairs

How about pretending that you and your partner are in fact illicit lovers meeting in a love hotel for a quickie? You must act like lovers when checking in and arrive and leave separately. One of the partners must be the dominant one and make the other feel guilty about their double life.

Restaurant

Restaurants can be very exciting. The dominant should decide a few rules before the dinner, such as not letting the submissive speak to anyone including the waiter. The submissive can only speak through the dominant partner. The dominant should probably decide what the submissive should eat and how much. If you're feeling brave the submissive partner could be blindfolded and fed.

Handcuffs in a public place

Handcuffs (Lust Films) is based on a real life role-play witnessed in a restaurant in Barcelona. It's very exciting to play roles in front of people you don't know (handcuffs.lustfilms.com).

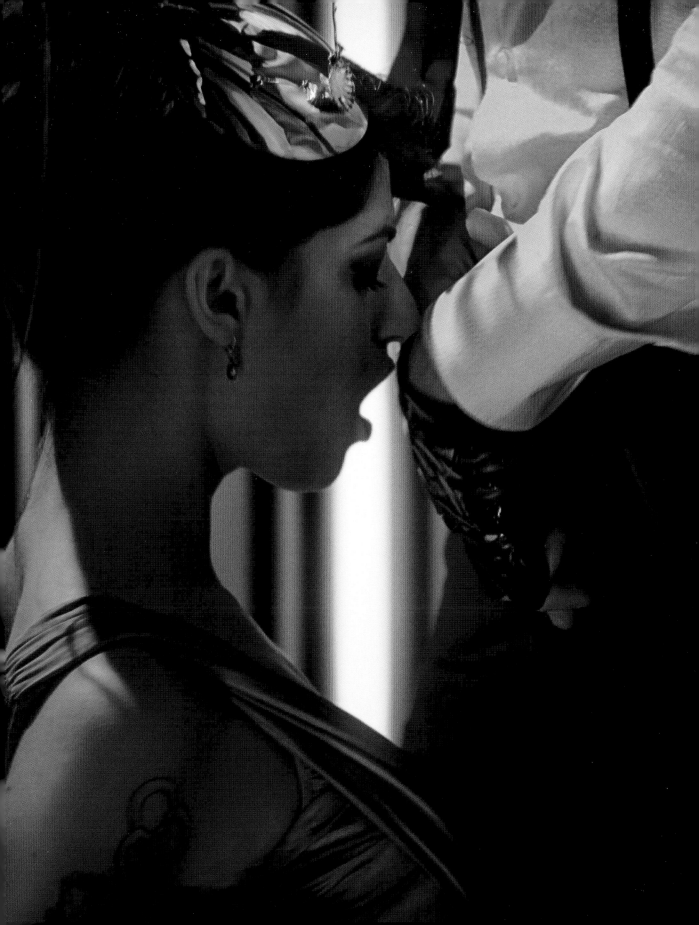

MASTERS AND SLAVES

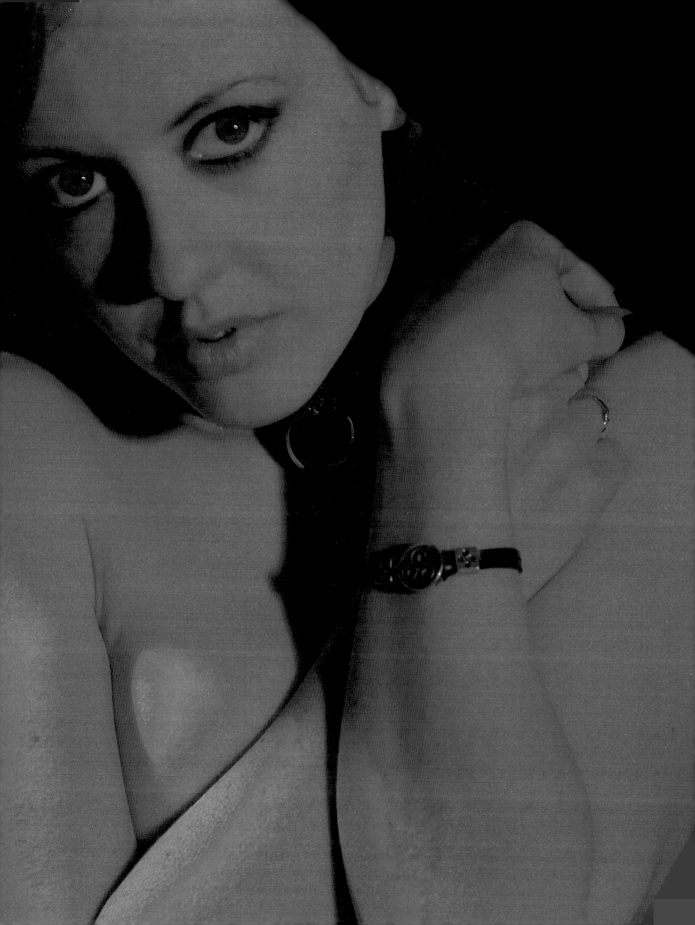

>>> >>> Masters and slaves

For some, masters and slaves is role play. For others, it's a way of life. The master-slave relationship involves one individual giving another complete authority over them. The master owns the slave and the rights to their body and makes decisions for the slave. The master-slave is a consensual relationship. Where sex is an aspect of the master and slave relationship, it does not necessarily have to be BDSM style, it could be perfectly conventional. Non sexual activities could involve cleaning, running errands, driving and whatever comes to mind. The master/mistress could delegate anything they can't be bothered to do themselves. Some master and slave relationships even take place on the web and the master may never meet the slave in person.

>>> Symbols of ownership

There are various symbols that are sometimes used to affirm the owner-slave relationship. The slave may have take on a slave pseudonym and even sign a slave register.

Collars

Collars worn on the neck of the submissive are used as a symbol of ownership. They are often owned and attached by the dominant as part of a ceremony and they are treated as a symbol of the highest respect. The standard collar is a black leather band with a metal ring allowing the attachment of a leash. Many people uses real dog collars with a buckle. You can buy dog collars in hardware stores. Other materials include PVC, rubber and metal. Many collars often feature buckles, straps, hooks and sometimes padlocks.

Contracts and ceremonies

An exciting way to formalise a master-slave relationship is to draw up a contract that defines the relationship in explicit detail. Such contracts contain promises of both the slave and the owner. The owner of the contract promises never to act in a way that would bring physical or mental harm upon their slave. Remember that BDSM is about consensual acts. Power should never be abused in any way. A true dominant will not hurt their slave, no matter what the scenario.

Contracts may include details of domestic cleanliness, home duties, who uses the bathroom first in the morning, who gets the best chair for watching television and so on. They may also describe sexual arrangements, rules and punishment, as well as other duties.

Submission contracts

The following is an extract from *Venus in Furs*.

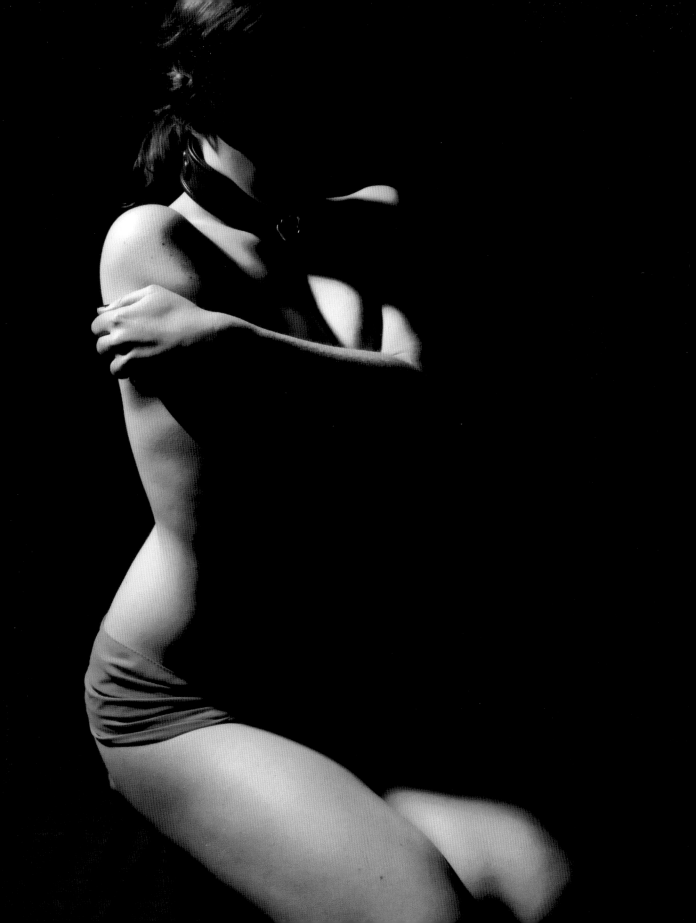

AGREEMENT BETWEEN MME. VON DUNAJEW AND SEVERIN VON KUSIEMSKI

"Severin von Kusiemski ceases with the present day being the affianced of Mme. Wanda von Dunajew, and renounces all the rights appertaining thereunto; he on the contrary binds himself on his word of honor as a man and nobleman, that hereafter he will be her slave until such time that she herself sets him at liberty again.

"As the slave of Mme. von Dunajew he is to bear the name Gregor, and he is unconditionally to comply with every one of her wishes, and to obey every one of her commands; he is always to be submissive to his mistress, and is to consider her every sign of favor as an extraordinary mercy.

"Mme. von Dunajew is entitled not only to punish her slave as she deems best, even for the slightest inadvertence or fault, but also is herewith given the right to torture him as the mood may seize her or merely for the sake of whiling away the time. Should she so desire, she may kill him whenever she wishes; in short, he is her unrestricted property.

"Should Mme. von Dunajew ever set her slave at liberty, Severin von Kusiemski agrees to forget everything that he has experienced or suffered as her slave, and promises never under any circumstances and in no wise to think of vengeance or retaliation.

"Mme. von Dunajew on her behalf agrees as his mistress to appear as often as possible in her furs, especially when she purposes some cruelty toward her slave."

Appended at the bottom of the agreement was the date of the present day.
The second document contained only a few words.

"Having since many years become weary of existence and its illusions, I have of my own free will put an end to my worthless life."

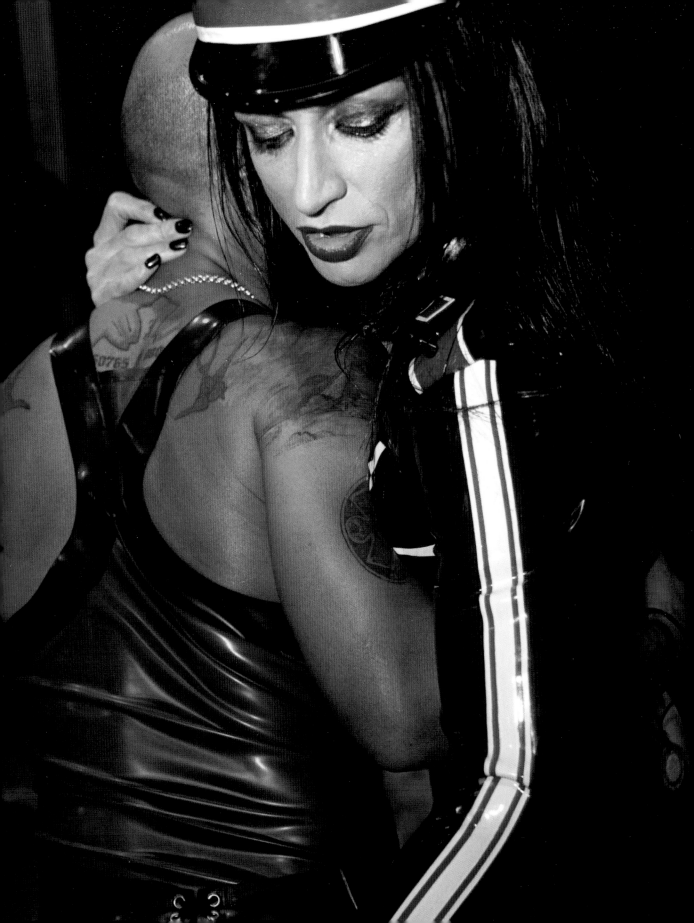

Here is another sample dubmission contract. Some contracts have more "blanks" which in some cases are not filled until after the slave has signed the contract. The contract signing may take place in a collaring ceremony. For some, such ceremonies are considered an alternative to marriage.

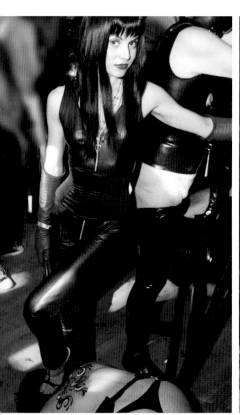
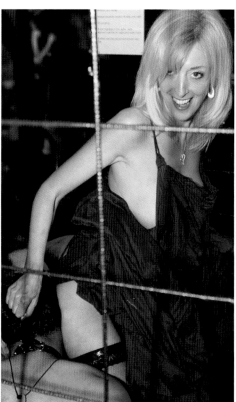
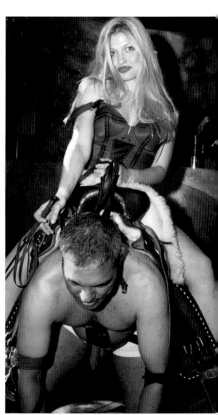

100% SUBMISSION CONTRACT BETWEEN _____ **AND** _____

_____, hereinafter referred to as "OWNER", hereby binds this contract with [his/her] signature and the signature of _____, hereinafter referred to as "SLAVE".

The SLAVE agrees to the following conditions as stated in this Submission Contract.

Duties

SLAVE must please OWNER at all times.

SLAVE agrees to complete any command from OWNER.

Personal Duties include but may not be limited to: Attending to physical/emotional needs of OWNER, amusement, sexual plaything, physical comfort, obedience, honesty, loyalty, waiting on OWNER as desired and needed.

Household Duties include but may not be limited to: Cleaning and keeping the home tidy, laundry, shopping, cooking, running errands as needed. Any assigned tasks are considered permanent.

Training

SLAVE agrees to be trained in any manner the OWNER wishes.

Behaviour

SLAVE shall address OWNER as _____ at all times.

SLAVE shall pay full attention to OWNER when spoken to.

In Private:

SLAVE will not use furniture without permission of OWNER.

SLAVE will not go to the bathroom without permission of OWNER.

SLAVE will not get into or out of bed without permission of OWNER.

SLAVE will not eat or drink without permission of OWNER.

SLAVE will be clean at all times.

In Public:

SLAVE shall remain within eyesight of OWNER unless permission is given to do otherwise.

SLAVE shall not argue or complain when in public with OWNER.

SLAVE shall be polite and prompt at all times, showing OWNER full respect.

SLAVE will never interrupt OWNER, or others when speaking.

SLAVE shall never embarrass OWNER in any way

Punishment

SLAVE will submit to any discipline or punishment OWNER sees appropriate.

This might include, but is not limited to:

Spanking;

Prolonged bondage or gagging in any manner OWNER chooses;

Being forced to sleep on the floor, in chains or bondage as OWNER sees fit;

Deprivation of social activities;

Assignment and completion of punishment tasks;

Humiliation;

Insults.

Duration

This Contract is valid from this day until _____, and then it may be renewed or renegotiated if OWNER and/or SLAVE feel it needs to be reviewed and updated. At that time, the SLAVE will receive a new contract.

SLAVE agrees to the above provided the OWNER does not expose the SLAVE to any physical, psychological or legal dangers.

Accepted, understood and agreed to on _____,20__

SLAVE:

OWNER:

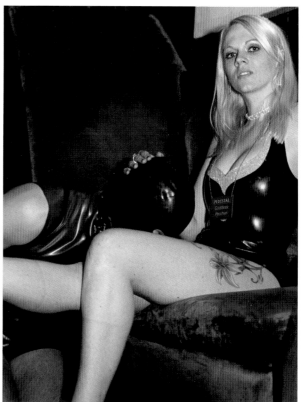

>>> Femdom

Femdom = female domination.

Femdom is where the female is the dominant partner. In Femdom scenarios femininity is celebrated and masculinity is condemned. Many activities associated with Femdom include boot worship, foot worship, facesitting, orgasm denial and, in more extreme cases, the forced feminisation of a male partner and strap-on dildo penetration.

Yes, My Mistress...

If you like the idea of having a male slave. Here are some ideas that you can put in to practice in the comfort of your own home.

"What can my slave do for me?"

Massage

Everyone loves a massage. Get your slave to give you a nice massage or a foot rub after a long hard day, without feeling that you have to give one back.

Manicure / Pedicure

It's always a chore to do this oneself, first show him how and make him do it while you relax.

Cooking

Make him prepare your favourite meal and then make him feed it to you. A cruel twist would be not to let your slave eat any of the delicious food he has prepared.

Driving

Use him as a chauffeur. Make him pick you up from a night out with the girls and make him drive you wherever you want and wait in the car alone while you visit your friends, shop or go out clubbing without him.

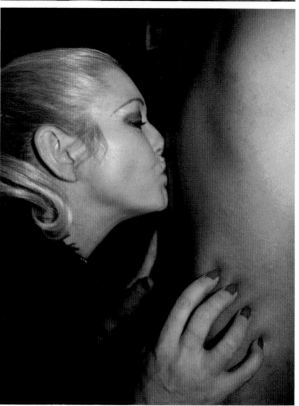

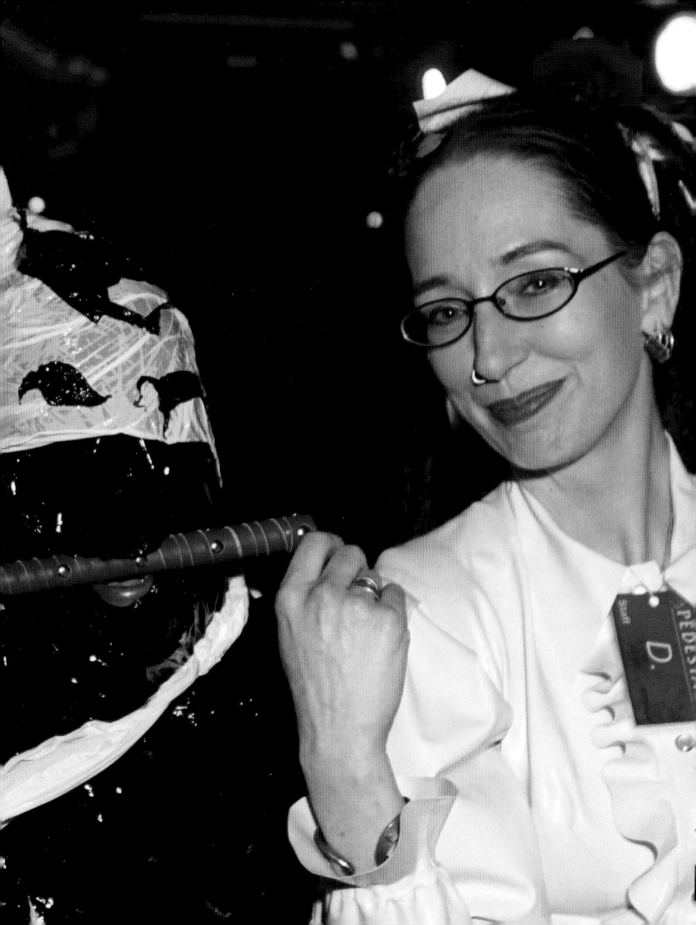

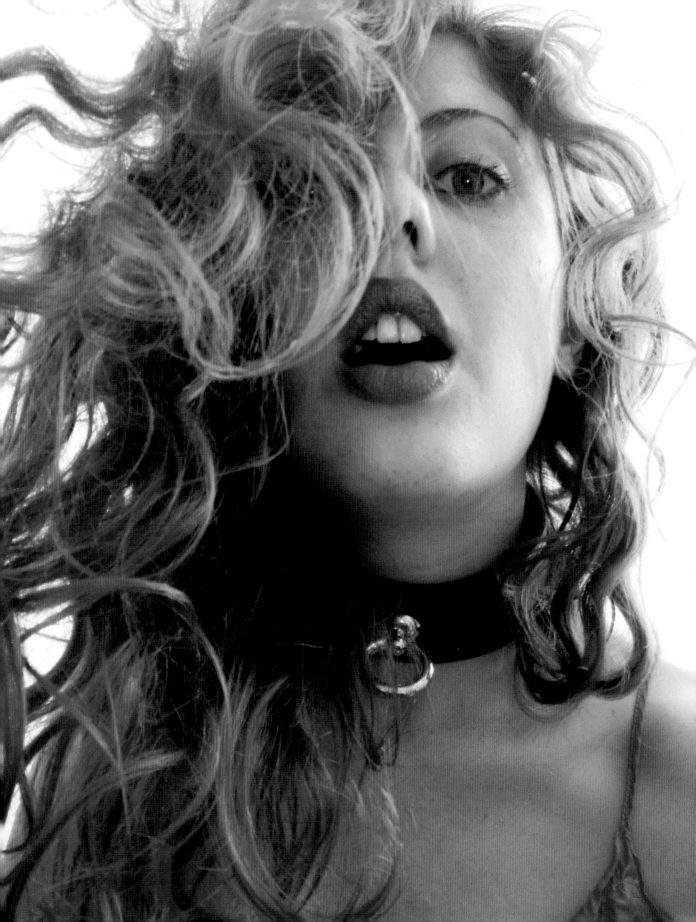

Shopping-bag holder

Most men hate shopping as much as most women hate football. Make him carry your bags and take him around as many shops as possible.

Secretarial duties

Make him organise your hairdressing appointments, doctor appointments, etc. Make him cancel your rendezvous if you need to. If you let him write your e-mails make sure he doesn't find out your password!

Foreplay with no afterplay

Unfortunately most men rush foreplay, so make him learn what you like without doing anything back. Order him, instruct him, be clear about your desires and correct his "mistakes" accordingly.

Femdom paradise – The Other World Kingdom

The Other World Kingdom (OWK) is a Femdom paradise set in a 16th-century *château* in the Czech Republic. The OWK has its own currency, flag and national anthem. It was founded on June 1, 1996 by Queen Patricia I. The OWK is governed on the basic principle that the WOMAN is always, everywhere and in everything superior to the male creature. In the OWK women have the right to own and use slaves, male enslavement is practiced both in public and in private. Sounds good?

If this sounds like a dream come true, then why not visit? The OWK has been open to the public since 1997 and is designed for mistress and slave couples, groups of women with slaves, and singles who are curious to take part in social events either passively or actively.

For the daring, it's possible to arrange birthday celebrations and even wedding receptions in the Queen's Palace. The accommodation is equipped with many BDSM items of furniture such as slave-cages, spanking benches, wall-crosses, prison cells as well as many basic punishment aids.

Check out the OWK website for more information.
www.owk.cz

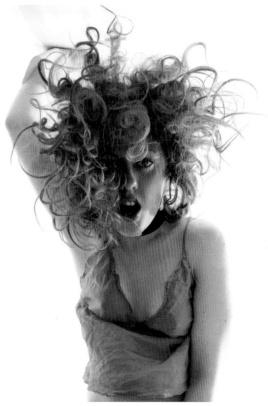

Club Pedestal

Club Pedestal in London is a monthly event that caters for the entertainment and enjoyment of women. An exciting feature of Club pedestal is the House Slaves. They can be identified by their red collars and they will take care of everything from getting your drinks to polishing your boots as well as being used as pedestal.

Fetishwear is encouraged and there are even slave collars on sale at the door. Check out the Club Pedestal website for more information.

www.clubpedestal.com

Venus in Furs – Velvet Underground

Shiny, shiny, shiny boots of leather
Whiplash girlchild in the dark
Comes in bells, your servant, don't forsake him
Strike, dear mistress, and cure his heart
Downy sins of streetlight fancies
Chase the costumes she shall wear
Ermine furs adorn the imperious
Severin, Severin awaits you there
I am tired, I am weary
I could sleep for a thousand years
A thousand dreams that would awake me
Different colors made of tears
Kiss the boot of shiny, shiny leather
Shiny leather in the dark
Tongue of thongs, the belt that does await you
Strike, dear mistress, and cure his heart
Severin, Severin, speak so slightly
Severin, down on your bended knee
Taste the whip, in love not given lightly
Taste the whip, now plead for me
I am tired, I am weary
I could sleep for a thousand years
A thousand dreams that would awake me
Different colors made of tears
Shiny, shiny, shiny boots of leather
Whiplash girlchild in the dark
Severin, your servant comes in bells, please don't forsake him
Strike, dear mistress, and cure his heart

CYBERSLAVERY
Collar Me
If you're looking for an owner or a slave, check out
www.collarme.com – the Facebook of BDSM!

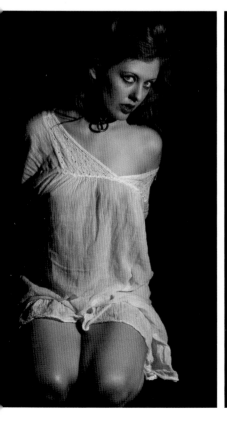 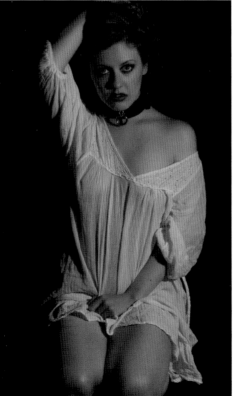 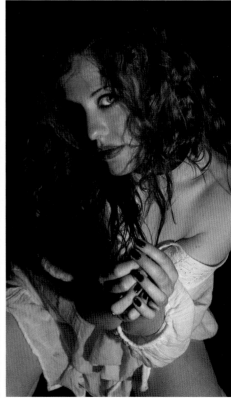

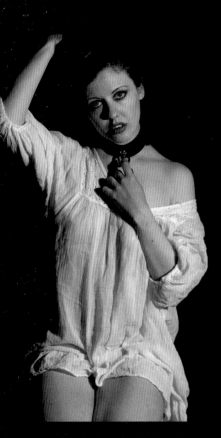

>>> A master's confession

Let's not forget that sometimes men have the reigns of power in owner-slave relationships. The following is a confession from a married lawyer in his fifties who lives out his sadistic fantasies with a slave on the internet.

Time difference
I opened the little package with my antique letter opener and tipped its contents out onto the simple cotton dress that covered my study table in lieu of a proper cloth. I handled the leather collar in my clammy hands before I raised it to my nose to smell. She had worn it around her neck for weeks, awake and asleep, before she had included it, gift-wrapped in tissue paper, in the package. I retreated into the luxury of my ante-room and placed them, fastidiously, inside my secondary floor-safe along with the other trophies that had been sent to me by my obedient doggy. It was with a sense of pleasure and a hint of regret that I closed the door and secured it again. When I had sufficient time in between consultations I would enjoy my gifts anew. As I reviewed the studied untidiness of my private room, I remembered the staunchly prohibitive Catholic education I endured as a serious-faced child and I smiled at the acidity of the memory; my mouth shrank with the tartness of the taste, in sympathy. My stern teachers had been right in their way, we all need faith; but devotion can display curious and satisfying mutations sometimes. I adjusted my collar and tie in the oval mirror and, as I passed through the connecting door into my official chambers, I assumed the lawyerly veneer that seemed to placate every one of my high-end clients, easing their fears about the capriciousness of the world and reassuring them about the cleansing powers of a "not guilty" verdict. As I nestled into my leather seat behind the glossy hulk of my antique desk, I reflected on just how much like a museum piece my professional demeanour must appear. Sometimes I needed to be behind glass when meeting my clients for the first time for, although referred to me by people I trust, they nevertheless succeeded admirably in turning my stomach with their hypocrisy.
Last night she pushed her tanned and taut midriff into the vista contained by the webcam and swayed from side to side inducing the lead attached to her collar to swing back and forth. I enjoyed watching our time together marked off by the passing of the strap from left to right across the small screen. She whimpered and sighed at the duration of her duty but she did not stop until I re-commenced typing and told her to do so.

 My wife had become a sedate cruise ship instead of the arousing tea-clipper that I had married. We had been nursed, shepherded and driven into the inevitability of fettered wedlock by the ministrations of our devout parents and our respective priests. Both wrapped-up tightly in our mutual virginity, we suffered the lack of any humour or delight in our metronomic contact beneath the heavy sheets of our perpetually darkened bed. That absence of sensual light persisted for years and mutters in my mind still. I craved the knowledge that illumination and definition provided so I was obliged to find it elsewhere. The task was a long one and fraught with disappointments, set-backs and empty epiphanies yet I persisted.
Using the extra-spill dog bowl that I had custom ordered and had mailed to her address in Chicago by a discreet third party vendor, she made hard work of drinking her cranberry juice to my satisfaction. From time to time she was forced to break off and gulp down mouthfuls of air before she pushed her juicestained face back into the bowl to

resume drinking, noisily. I permitted her to wash the bowl and dry it before she spooned a heap of chilli into it. I typed a reminder in case she forgot to say grace. She mouthed the words and commenced to eat with her hands held behind her back. The mess she made thrilled me intensely. Her glowing embarrassment, frustration and trepidation at my reaction to this turn of events combined to leave her in a taut limbo. I kept her waiting for ten long minutes before I explained the nature of her forfeit to her.

My education, legal training and subsequent career developed in inverse proportion to my unfulfilled desires but that was all right, because I could subordinate my off-kilter libido with research, cases, court appearances and private clubs. London has always been a portmanteau trunk constructed from hidden draws, sliders and elegant niches and all that is required to discover their secret switches, pressure points and combinations is an indebted guide, embarrassing evidence against him, connections to grateful thugs and lots of clean cash. Resources were never a problem for me; visibility always was. I watched the pierced and tattooed girls as they danced, stripped and posed with their pale, disinterested, disappointed faces and coldly futile futures waiting around the corner. These hasty pleasures were the definition of an empty confection; sweet and crisp on the outside but with an unsatisfying absence of illicit fulfilment at the centre. All those hours spent in pursuit of an elusive delight were temporary balms to my curtailed needs and were hardly more than mildly diverting, it must be said. Even now I wasn't unbuckled enough from my programmed morality to be unfaithful to my wife. I bore the weight of my unrealised ambitions in the solitude of my chambers for years. It was only much later that my cherished nocturnal interests could be fused with a necessary anonymity. I was a familiar face to the tabloidloving masses and I had to be careful.

It was sub-zero in Chicago and the poor excuse for heating that her landlord provided in his largesse, was less dependable than the occasional cockroach passing through, trying to find a warmer holiday home and coming up short. In her home country she had been an anonymous statistic in a vast typing pool. The company she worked for cared little for maximum working hours and even less for the long-term health of its female workforce. She wore orthopaedic gauntlets from time to time when her repetitive strain injury was afflicting her. Today she had the bitter cold and her R.S.I. to contend with but I paid no heed. She didn't raise an eyebrow when I set the conditions. She merely complied and had to sit naked and shivering, as I obliged her type harder and faster than ever before. She was clearly in great pain but she kept up her instant messages to me with perfect speed and clarity. Before we signed off she thanked me for my kindness and barked.

In my heyday, pornography was of the print variety; only later did the dubious delights of VHS videotape, DVD and Blu-Ray provide a more intense, vicarious experience. It was still insufficient for my tastes, however. The home PC revolution was the perfect medium for me to investigate the limits of my fascinations and through a strange hybrid of the worldwide web, my contacts and several auxiliary bank accounts, I became acquainted with the online availability of a craving surplus of submissives in every shape, colour and pre-disposition. That's where I found Ania and I had been in a pseudo-religious reverie ever since.

Ania drew the word "woof!" on her naked left breast and left it on there for days and days; every time she logged in she pressed the fading letters into the camera and rubbed her nipple with a blue, rubber, dog bone. As I had insisted, she began to wear her watch on the other wrist, arranged her hair in my specified but ever altering preference and washed more and more irregularly. Small packages began to arrive from Chicago wi-

…rmail and they contained the items I requested and in the condition that I required. Half eaten dog biscuits, used collars and whistles she had worn around her midriff. …ould not have been happier; everything was finally achievable in the way that I had always envisaged.

She was a lapsed Polish catholic, living with her solid Russian husband and expe…riencing the same lack in her life that was so familiar to me. Her spouse worked two jobs and was rarely home; content instead to guarantee a better future for his wife in the United States by never seeing her. A natural sub, she was unwilling to starve her imagination by waiting for her once a week servicing by the exhausted sausage machine that the man she married had become. He indulged her with the broadband connection and was delighted that he didn't have to sleep with her so often; that she had found an interest that really engaged her. We both shared a pro…found distaste for dishonesty in our respective realworld relationships and found a connection, across the Atlantic that fused us into a virtual dance from which we manufactured miracles--real miracles, not the false hopes peddled by those Bible stories that we both despised.

Ania was obligated to stream me a video clip at 6 am, 12 noon and 6 pm, my time every day, reciting the Angelus--a Christian devotion in memory of the Incarnation. A… she was approximately 7 hours behind the UK in terms of time zones this led to some bizarre occurrences, discontinuities and narrow escapes that made me smile, even now. She never missed a check in though and was guaranteed to recite as versicle and response three biblical verses. At the noon performance, she was required to call me on her cell phone and growl into the hand-set as she assumed a position that merged piety with being my pet.

It was my contempt, creativity and contractual obligations that she thrived on and I was committed to supplying exactly that rich mixture. In return, I was reassured of her compliance, willful self-abasement and continued ability to amaze, confound and refresh my most intuitive ideas and expectations. My respect for her was based almost completely, on her lack of respect for herself. She was the real thing, an im…plausibly exotic monument to my own betrayed religious convictions, cast in soft and supple flesh. I began to toy with a notion that might prove to be the ultimate test of the singular dynamic that hung in the blue skies between our respective continents. I contacted a notorious cartoonist whom had been a client of mine in a defamation case. He was only too glad to provide some sketches for me and, after a month or so, I selected the design that made the back of my head burn with satisfy…ing guilt and the perception of a singular sin realized in sinister ink.

Ania rose from her seated position and pulled her t-shirt out from her waistband with studied attention to my desires. She took great pains to delay the progress of the shirt a… she pulled it slowly, very slowly, up the exquisite curve of her tanned and toned midriff. She stopped, held the material in place for just a moment and then raised it from her obscured navel. There it was; the design I had sent to her along with sufficient funds to guarantee that a great tattoo could be produced from it. The ink-work, portraying a little cartoon dog taking confession stood sentinel on her belly, incorporating her navel into its design. It thrilled me still and Ania flaunted its profanity with abandon. She caressed the scene of the graphic crime and swung a rosary from her smiling mouth a… she began to dance.

There seems to be no way to contain my Polish slave; she's going from strength to strength and I am hard pushed to stay ahead of her sometimes. Nevertheless, I in…

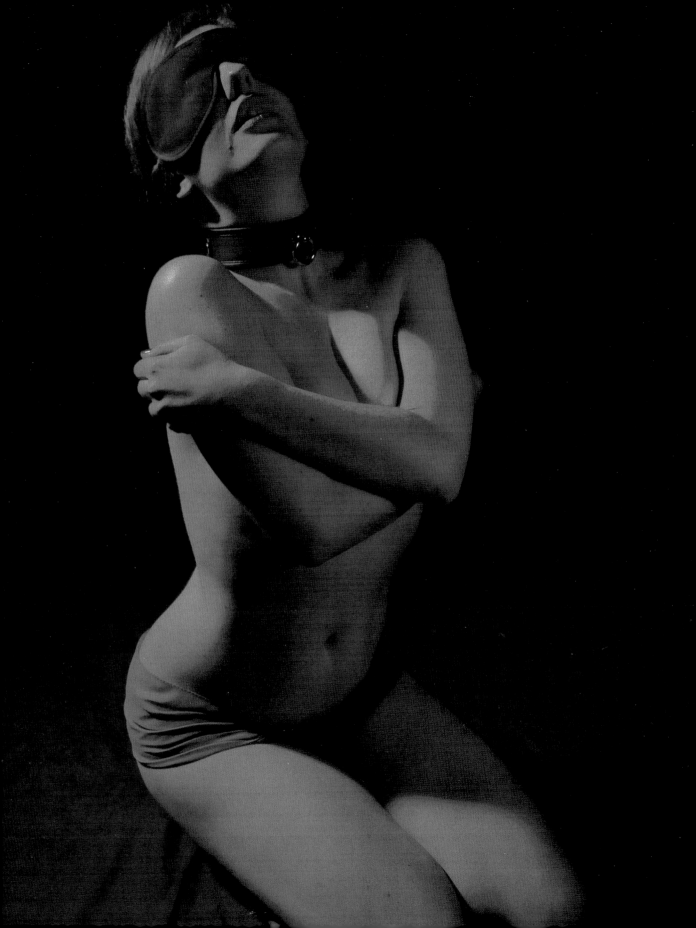

sist on praising my virtual pet in every way possible; by abusing her, criticising her and keeping tight and ready with my studied dismissiveness. She is my creature as I am hers. I notice that it is almost noon according to the office clock. A red icon appears on my tool bar as a signal and I retreat to the security of my sub-room. With my usual flush of colour in my cheeks, I log-on to our encrypted messaging service, warm up the webcam and slide the bespoke headphones over my ears. Her icon appears in the corner of my monitor screen and I accept her offer of a webcam session. After a small delay she appears on my screen, wrapped in her dog blanket. I type a demand that had just entered my head and she nods her unwashed face. She disappears from the screen, returns with a can of dog food and assumes her position on the floor holding the can out towards me. Ania pouts and blows a kiss as the Angelus commences and I smile back, unseen.

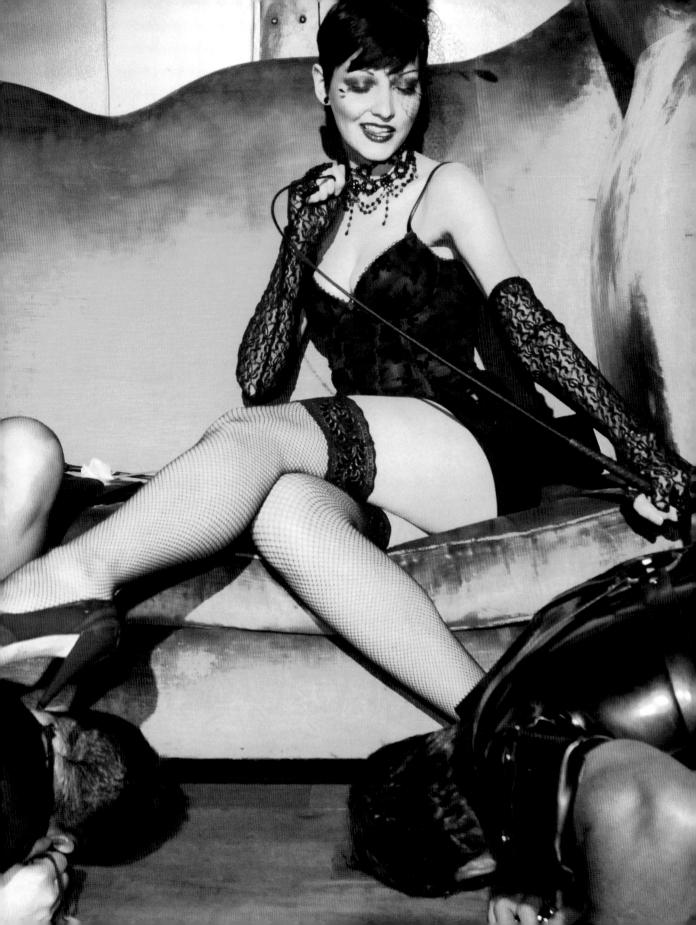

>>> A slave's confession: a male sub goes to extreme lengths to prove how much he adores his mistress

Checklist

"The scent of fresh bread is always finer than the reality of a bought sandwich."

She was astounded with the contents of the pamper box when She opened it; finding each of the items wrapped in tissue and tied with ribbon. She reviewed Her list of demands and drew red lines through them; cucumber facial scrub, name-brand bras, English sweets, chocolate bars, shorts, perfume and latex accessories. It was all there. She had lined up the booty on Her punishment table, dug to the bottom of the carton and found something She wasn't prepared for; a jewellers box containing a choker made of silver spike-clusters. As She examined the craftsmanship, She made a decision to break her carefully established protocols. She composed a brief email and sent it. For me there was an unending thrill in my unrequited devotion to Her perfect beauty. I opened my in-box and found the non-system reply floating there. I tried to dismiss the possibility that it was Her but when I read the tiny text there was no doubt about it.

Within the cloistered world of internet BDSM networking sites it was a given that the pinnacle of self-realisation could only be found by following that near legendary figure of Wanda. Although She had an easily accessible DogBook page, it became clear to Her worshippers that the proof of devotion She demanded of them only increased over time. Many subs were set tasks that were beyond them. Others became Her unappreciated slaves and were held in high esteem because of it. I had made my slave request on DogBook like every other sub and was accepted. She lived Her ethos of realisation through the intelligent application of discipline and my soul burned with the truth of it. I wrote messages to Her general email address and, in my vulnerability, I found a voice that became integral to my happiness. I extolled Her beauty and thanked Her for permitting me to find myself anew in my worship. "Should you ever read my words, I beg you to know that you are my reason to breathe." I clicked on "Send." I received a reply from Her site and was in bliss. "Write only to prove your worth to me", She had explained.

When I volunteered that I was resident in London, She required that a pamper box be sent to her offices in Paris and went on to explain that She had lived for a time in Brighton where She had trained as a teacher. Certain items reminded Her of those days and I would fail in my duties if I didn't heed this. I had come up a little short as Her email had pointed out but it had been sent from Her personal email for the first time. "The chocolate bars were in multi-packs, not bought individually", She wrote tersely. The accomplishment of earning a personal email from Her turned into corroded metal. The CD that I had bought on Her instruction played in the background as the room temperature dropped; its melodies became a funeral dirge for my hopes. I barely noticed another message appear. I opened it and read it through watery eyes. "You have sinned, true, but I understand weakness", the text read. My heart caught fire once more and the dirge became a wedding march. "The Goddess is kind and I would make amends", I typed. "Wait", She ordered. "Clean my flat and prove your worth." She continued a full two hours later. I almost burnt in my own furnace of pure pleasure. "Eurostar would bring me to your door in only a few hours." I volunteered. "Too comfortable. Fly the worst airline with other livestock…and smile", She typed. "I am your creature and will do as you say, with

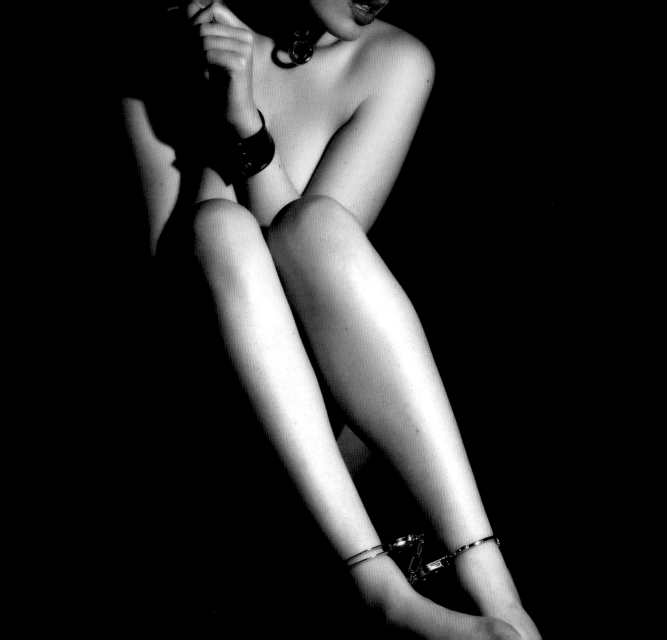

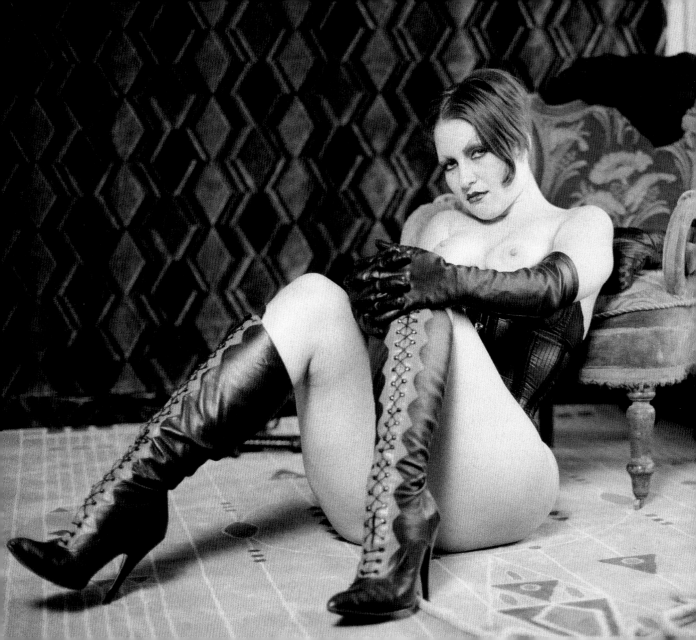

fortune and tenacity I found the correct train route to Paris. The prevailing aroma was one of unwashed tarmac after a week long street party. After getting the RER train from Orly to the Gare du Nord, I changed to the Metro. I called to mind the cardboard taper I smelt yesterday before purchasing the designer fragrance for Her parcel and I pondered the strangeness of a metro train that ran on tyres. The other passengers stared at me as if I were a bad sample on a laboratory slide. I alighted at Blanche, in front of the Moulin Rouge barely noticing the exhausted rows of sex shops in the Boulevard Clichy as adrenalin urged me on. I strode up the steep hill of Montmartre and I was compelled to halt when Her faxed sketch map eluded my understanding. I realised that the map had been drafted back to front and I held it up to the light to interpret it.

My pace increased again and I reflected briefly that a chase can never be mundane when minutes burn away as brightly as these. When I found the strangely dilapidated building I released my held breath but quickly discovered that it was protected by a digicode that my Goddess had not supplied. I would have to improvise and avoid conjuring up the spectres of my checklist and the rigid return flight schedule and used the time to explore probabilities and alternatives. Then I noticed the elderly lady leaving the tired building and I ran; relying on her infirmity and my velocity to give me the turn of luck that I needed. She muttered darkly through her wheezing breath as I lunged past her with a scream of delight. The lift within had been recently and expertly vandalised leaving only a flight of waxed stairs between me and Her apartment. I slid and clambered up the stairs without hesitating and in minutes I was rapping on Her blistered door. My vision dimmed as it opened.

It wasn't my Goddess at the door but a servant girl in black bodice, choker and knee length boots who curled her lip and wrinkled her nose as if a piece of sweaty cheese had been wafted beneath it. Wasting no time with words she led me inside through an arch made from rusted bedsteads with patterns of scratches on their surfaces. I placed the parcel beside it. I was not permitted the time to focus on anything before I heard a nearby voice with a distinct and hypnotic fusion of English and French at its heart. "Show it the cleaning materials," the voice purred.

I noticed a figure dressed in wrinkled pyjamas, without make up and with loose and unkempt hair. She moved out of sight as I became aware of the atmosphere of Her space. Cigarette smoke wrapped itself around pungent incense, wine fumes and a lurking aroma of metal and latex. The servant turned me around a few times so that I could perceive the fetching squalor of the apartment and the amount of work required. Everything was in artful disarray with panties spread across the floor like a wrinkled cotton carpet, cuddly toys heaped in misty corners and furniture pushed askew. I noticed the pyjama girl seated at Her desk, typing and sighing to

tercom on the wall. I saw the figure in pyjamas drift past the doorway and heard a door closing through the intercom. As I began to clean I heard the rustling of linen, a draw being opened and the squeak of a bed. Then I heard a buzzing noise, sighing and moaning. As I scrubbed and polished, the moans from the intercom increased until they paused and resumed as shallow breaths and sighs. I was on my knees when Her feet appeared next to my braced arm. Another card was shown to my downturned eyes and I smelled Her sweat, felt Her heat and tasted Her echoes of contentment in my throat.

"Tidy my room while I shower", the card read. I crouched and waited for Her to depart before I jumped to my feet and went into the bedroom. It was a study in wretchedness within with its abandoned clothes, footwear, hairstyling equipment, and more bras and panties than I had ever seen, even in a department store. I picked up a suede boot that projected from beneath the bed and closed my eyes as I pressed my lips to its tip as I would the belly of a lover. I completed the pair and began with the bed. As I dismantled it I felt the tingle in my fingertips as I touched the warmth that remained from where She had laid. I leant down and brushed my nose against the pillow to smell the traces of Her hair.

As I built a better bed I heard the shower spraying the sweat from the body of my Goddess. I crossed my chest with Her initial and gave thanks. After fifteen minutes in the shower She appeared at the door in a dressing gown wearing a halo of fragrant shampoo, perfume and subtle moisturiser. She spoke to me for the first time.

"Clean the lounge", She demanded as She walked away, "if you wish to see your gifts on me." Her displaced voice teased. I entered the lounge but She was nowhere to be seen. I saw a distant flash of light and heard a sound that could only be a Polaroid camera in use. I counted five pictures taken nearby. My nervousness began to grow as my chores were completed and She chose that moment to re-emerge with Her hair tied back, dressed in old jeans, a hooded sweatshirt and wearing sports shoes. She handed me an envelope.

"Open it on the flight home and know it is my best one", She directed. I was dismissed and placed in the care of Her servant as She vanished from view. The servant fetched my clothes, saw to it that I dressed without delay and showed me out of the door. I found myself with three hours until my flight home. I was numb when I found myself at the airport and grew weary as the flight was delayed and the waiting stretched out as far as the horizon. The envelope burned in my pocket until I was seated in the aircraft and halfway home. I opened the envelope and found a single Polaroid photograph inside. It was a blurry image of my Goddess wearing the bra that, of the three I had purchased for Her, was the only one I had been permitted to choose myself. I raised the glossy square to my nose and smelt incense, tobacco

smoke, wine and shampoo. The cabin crew wondered why the middle-aged man seated in the worst aisle seat of all seemed to be happier than any other passenger that they had ever seen. Two weeks later, on Wanda's DogBook page, a photo-set was posted that comprised four perfectly clear, immaculately framed Polaroid images of Her wearing the bra that I had chosen. Curiously though, the set was advertised as having five discreet images and online speculation was rife about the fate of the missing frame. I raised my Polaroid to my nose and the aroma it wore embodied the finest sensual and philosophical experience of my life. As I emerged from my reverie and waited for Her imminent email I picked up the store-bought sandwich on the desk before me. It looked rough through the plastic, looked even rougher out of the plastic and tasted of nothing. Her email appeared and my appetite was sharpened to a point as I read Her demands. Her dismissiveness was my perpetual joy.

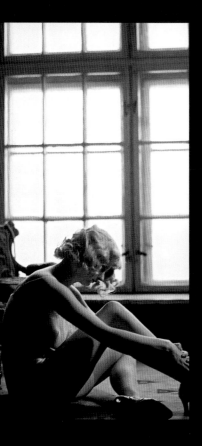

>>> Punishment
>>> What about rewards?

REWARDS AND PUNISHMENT

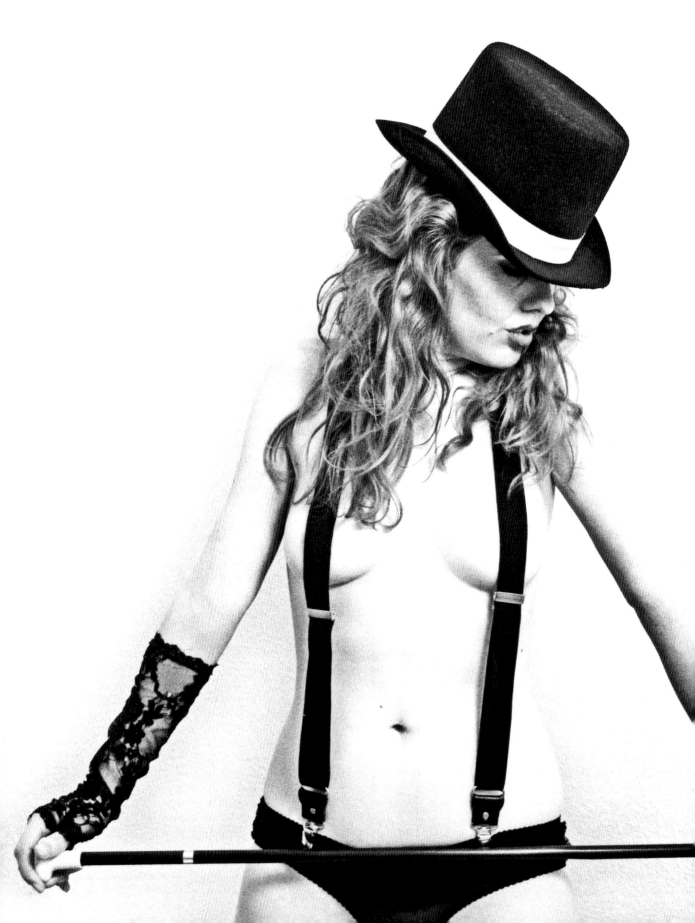

>>> Punishment

Punishment can be enjoyable for both submissives and dominants. Remember that it's all about having a bit of fun, and any punishment should not cause harm to the submissive.
Here are some exciting ideas you may want to try out on your sub next time you're in control.

Deprivation
Sensory deprivation

Tactile senses are enhanced when other senses are taken away. One way to make any experience much more intense is to blindfold your partner and also prevent your partner from hearing. Being unable to hear creates an interesting and often profound psychological state of disconnect from your partner, which can intensify your sexual experiences.

Cruel tip: use a blindfold in situations where he would really want to have full vision, i.e., the cinema, a football match or in a strip club.

Sensual cruelty
– Sight: blindfold.
– Hearing: earplugs.
– Touch: gloves, clothing.
– Taste: gag dipped in salt water or sour wine.
– Smell: clamp on the nose.

Comfort deprivation

Deny your lover of some modern comforts. Here are some cruel ideas:
– No hot water when it's bathtime.
– No comfortable sofa for watching the television, give your sub an uncomfortable stool or better still, make him stand up.
– Make the sub sleep on the floor while you sprawl out in your bed alone.
– Make the sub sleep in bondage.

Social deprivation

Ban your lover from meeting with friends for a week or even longer depending on how cruel you're feeling and how much punishment is needed.

Technology deprivation

Most people are lost without their gadgets these days. Here are some ways to be technologically cruel:
- No access to the internet or email accounts.
- No mobile phone. Answer it for him and say that he is unavailable. Always "forgetting" to pass on the message.
- No videogames.
- No television.
- No porn.

Sexual deprivation

Deny your lover his favorite sexual act for a limited amount of time, until he deserves it!

Movement deprivation
- Tie your lover up to some furniture.
- Tie the ankle with a long rope allowing him to wander around the house without being able to go outside.

Transport

If he loves his wheels, make him take public transport or walk.

Isolation

Make the sub stay in a small room for a couple of hours. Make sure the sub is not able to sleep by making them stand up.

For more information on administering safe physical punishment, see our next chapter on pain.

Forced feminisation

Forced feminisation is also known as "sissification." It describes the practice of switching the gender role of a male submissive.

It is usually achieved through cross-dressing, where the male is dressed in female clothes. It could range from wearing female lingerie to wearing make-up. Some males adopt tasks and behaviour that is overtly feminine as well as gestures, mannerisms and postures. Forced feminisation may be coupled with punishments such as spanking or caning to gain co-operation and humiliate the submissive male.

Humiliation

Humiliation is where one person gains arousal or erotic excitement from the powerful emotions of being humiliated or degraded, or of humiliating another.

Humiliation can take many forms. It can be physical or verbal, sexual or nonsexual and can take place in private or in public.

Verbal humiliation
- Human/animal role-play making them eat and drink from pet food and water bowls.
- Insults and verbal abuse.
- Degrading references.
- Criticizing body parts or mannerisms, such as cruel references to breasts, facial appearance, genitalia or genital size, bottom, and criticizing mannerisms such as walking, personal hygiene, and dress sense.
- Make the sub sing for you. You choose the song and then criticize their performance after.
- Mockery.

Physical humiliation
- Menial tasks such as cleaning the floors with a toothbrush.
- Subservient behaviur such as walking behind the dominant, only speaking when spoken to, kneeling in front of the dominant, eating only after others or on the floor.
- Foot/boot worship: kissing and/or licking the dominant's feet and boots.
- Restriction of movement. This may include never being able

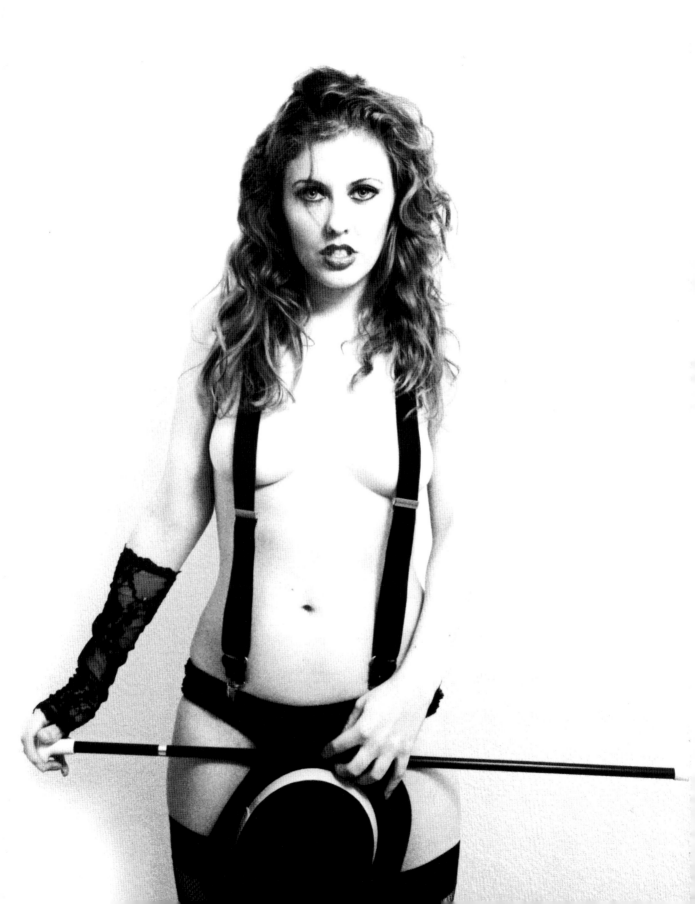

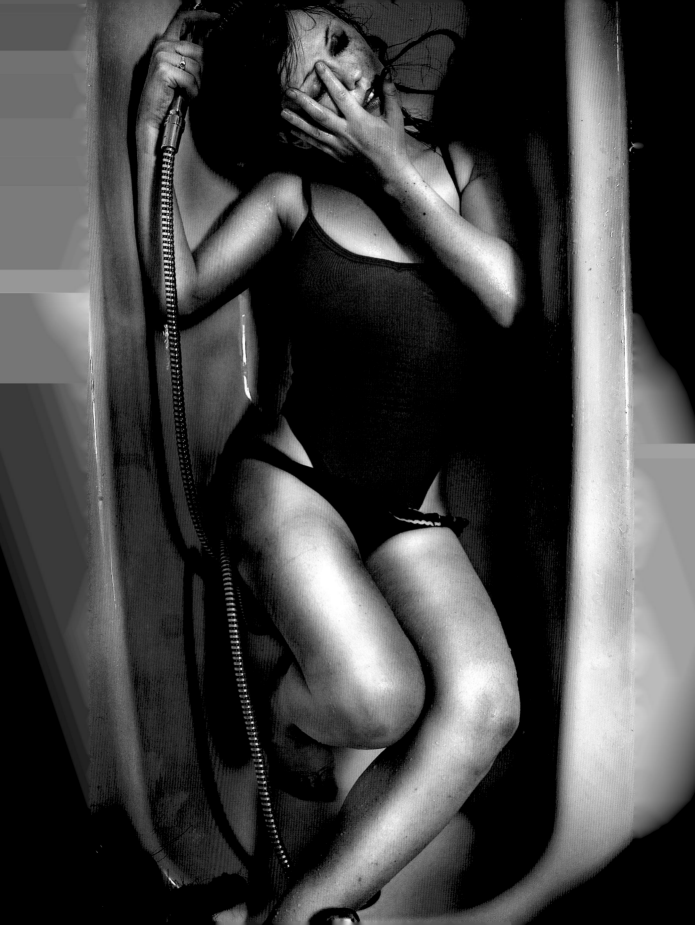

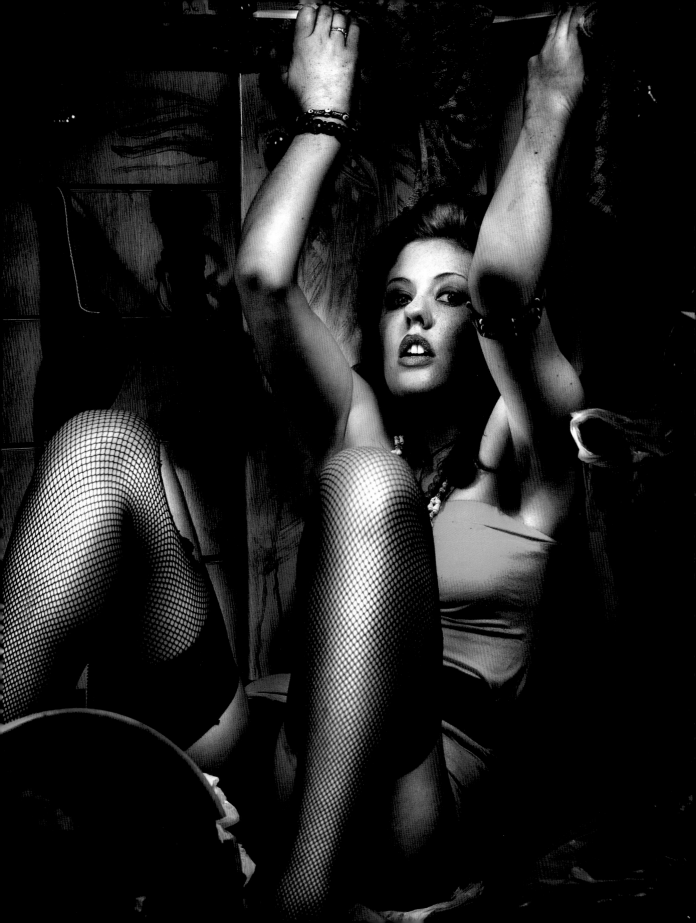

to leave the room in which the dominant is present without permission, having to stand in a corner.
– Wearing of "ownership" symbols such as a collar.
– Using the sub as a footstool.

Orgasm denial

Orgasm denial is a sexual practice and a form of power exchange where a person is kept in the plateau phase of the human sexual response cycle for an extended period of time. When an orgasm is denied continuously without knowledge of when that release will be, then the sub will soon be willing do just about anything to please the dominant.

Depending on the nature of the scenario, the sub may either be allowed an orgasm at the end (in which case, the orgasm will be more intense than usual) or deliberately denied one. If the denial continues the sub will generally be more sexually frustrated.

Cleaning

Make a real mess and then get your sub to clean it all up!

Indifference

For many subs, indifference is the worst kind of punishment. There's nothing worse than being ignored. When a sub finds their cries for punishment are ignored, it can drive them crazy!

>>> What about rewards?

We almost forgot!
If your sub has been good...
–A massage and bath.
– Favorite meal.
– Favorite TV show.
– A striptease.

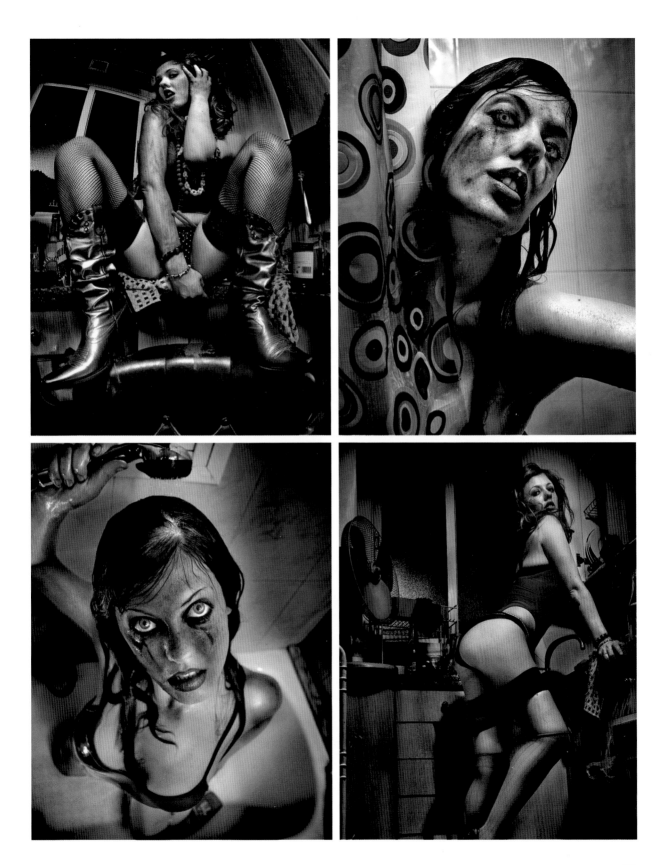

>>> Ouch!
>>> BDSM good pain
>>> Pain confession

NO PAIN, NO GAIN

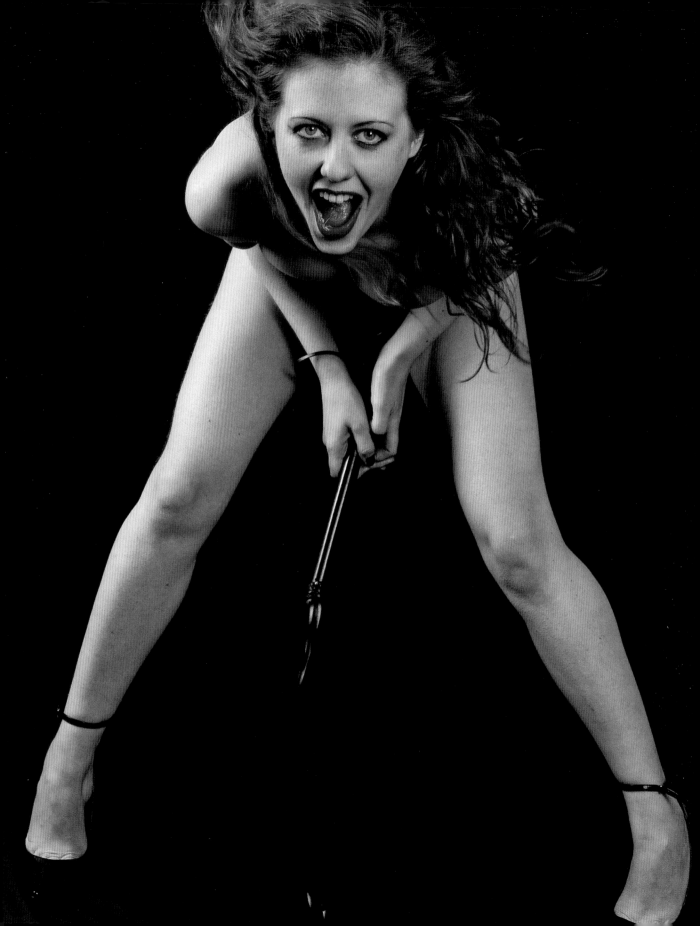

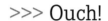

>>> Ouch!

Let's face it. Pain often occurs in the course of conventional love-making, particularly love-bites, scratching and hair pulling. To some people these may be desirable, to others maybe not, but it should be remembered they are, by and large, spontaneous occurrences in "the heat of the moment," whereas BDSM pain is deliberately applied specifically to increase sexual arousal.

Good pain
- Love: let's face it, love hurts!
- Being stiff after sport.
- Bruises caused by love bites.*
- Bruising/scratching after intense lovemaking.*

What is considered "good pain" depends entirely on you!

Bad pain
- Period pains.
- Headaches.
- Toothache.

Sex and bad pain relief
It's official: orgasm is a powerful pain-killer as well as a natural stress-reliever. When you engage in sexual activity or masturbate to achieve orgasm, stress can be reduced by the release of endorphins. Endorphins are powerful compounds that resemble opiates, and are also known to be the body's natural pain-killers. This is why sexual activity is often encouraged to cure headaches and menstrual cramps, as the release of endorphins can increase pain tolerance significantly. So next time you have some unwanted "bad pain" you know what to do! What about "good" pain...?

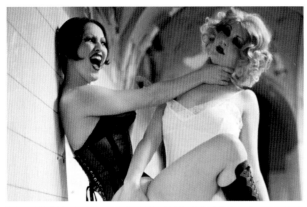
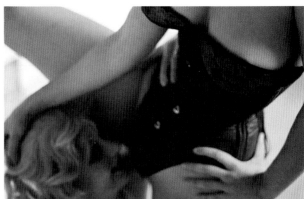
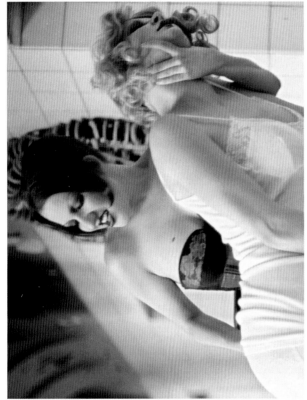
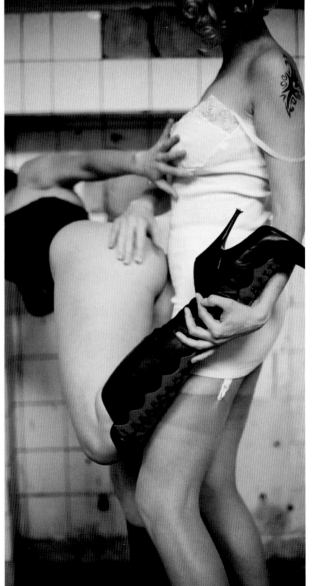
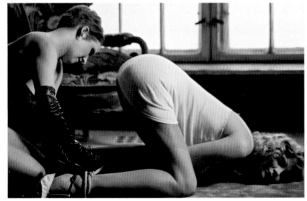

>>> BDSM good pain

Spanking

Spanking consists of striking the buttocks with a bare hand. Other implements may include paddles, rulers and sometimes hairbrushes.

Why is spanking exciting?

Spanking can be an exciting punishment as part of a role-play scenario. It can be just as exciting for the spanker as for the spankee. Just imagine a naughty school girl who needs discipline... For the "spankee" the anticipation before being spanked can be very arousing. Usually you can never tell the exact moment of the strike, so often spankees tense their buttocks in anticipation, which in turn stimulates the whole genital area. When the "slap" finally comes, the buttock area becomes red and warms up, creating a delightful sensation...

Spanking positions

- Over the knee (OTK).
- Bent over a chair, a sofa or a spanking bench.
- On all fours.
- Lying face down on a bed or sofa.
- Over the shoulder of the spanker.
- Lying on back with legs raised towards chest.

Spanking tools

- Bare hands.
- Paddles.
- Riding crops.
- Rulers.
- Hairbrushes.
- Spank bench.

Safety first! Try and stick to the buttock area and avoid the back.

Spanking tips

- Tease and confuse your partner with gentle strokes and caresses before the first "spank."
- Start off gently and gradually build up the rhythm and intensity. The more gradual, the longer the spanking session can last without the spankee being in too much pain.
- Switch between intense and gentle spanking.
- Be gentle after an intense smack, with some light caresses before slowly building up the intensity again.
- Use your imagination. Don't just say "you've been a bad girl." Try and decide WHY the spankee deserves to be spanked.

Spanking parties

If you're really into spanking, you might want to consider attending a spanking party. Such parties are not like typical BDSM parties. At spanking parties, bondage gear should be left at home, as fetishwear is not considered appropriate. Instead you will find people wearing smart casual clothes, although having said that you might see the odd spankee in school uniform. Expect to see a lot of red bum cheeks and to hear a lot of slapping! To find out more, check out Ms Margaret Davis' website (www.msmargaretdavis.com). She arranges spanking parties in New York once a month.

If you can't find one near where you live, why not organize a spanking party yourself?

You could place an ad online to find like-minded spankers and spankees.

The True Confessions of a London Spank Daddy by Peter Jones

Peter Jones is a lawyer in his fifties from London. He has written an addictive and fascinating book based on eight years experience as a spank daddy. He shares his secrets of liaisons with many women who needed some extra discipline. In each chapter he reveals his client's stories as he turns their fantasies into reality. Highly recommended!

The Art of Spanking by Milo Manara and Jean-Pierre Enard
Milo Manara is an Italian erotic illustrator who published the legendary *Art of Spanking* in 1989. The inspiring artwork is accompanied with texts written by Jean-Pierre Enard. The book is an excellent beginner's guide to spanking.

Whipping

Many people who are new to BDSM are often afraid of whipping. Whips can provoke a series of sensations depending on its materials and weight. They can caress, massage or punish.

Be careful! Whips are weapons: practice on a pillow before hitting your sub.

Different strokes for different folks

With bare-hand spanking, paddles and canes, you can hit with any force you like, from a gentle caress to a hard blow. However, with a whip there is a minimum speed for hitting. The impact depends on the weight of the whip and its speed when it hits the target. Different whips cause different sensations, and many dominants have several whips.

Whips vary according to length and materials:
- Whips made from softer leather like suede at most can redden the skin.
- Heavy leather whips can bruise and even cut the skin.
- Rubber whips and horsehair cause more of a stinging sensation.
- Some are made from small chains and should just be used for caressing the skin.

Whip tips

Before you start
- Talk to your partner about what sensations you like.
- Once you've decided what you would like to do, establish the limits.
- Any medical or physical problems should be made known beforehand.
- Invest in a good quality whip.

- Avoid one-tail whips to begin with, as these cause the most pain.
- For more control of the sensations, use shorter whips.
- Practice on a pillow so that you understand where the tails will hit.
- Be aware that there is a big difference of impact if the submissive is lying down as opposed to standing up.

During
- If the whip is made from real leather, make the sub smell it before doing anything.
- Pass the tails over the skin lightly caressing and almost tickling the skin.
- Start with softer blows and work up gradually to harder ones. This way the sub will be able to take more as well as get more out of the session.
- Watch the reactions of the sub carefully, especially the effects of the tails on the skin.
- Alternate caressing with the whip with hitting.
- Target the back, the buttocks, the thighs. Stay away from the joints of the legs and arms. You should never whip the head or neck area either.
- Don't try any complicated strokes. Play safe.
- Avoid "wrapping" where the tips of the whip wrap around the body. This can be very painful.

After
- Check the sub's skin for any damage.
- Get feedback. Ask the sub what it was like.

Nipple clamps

Nipple clamps can be used on other parts of the body as well as the nipples. They can also be used on men as well as on women. However, due to the increased sensitivity of female nipples, they tend to be a toy for the ladies. There are many types of nipple clamps to choose from, including the good old clothespeg. They might not look as good, but they do the trick.

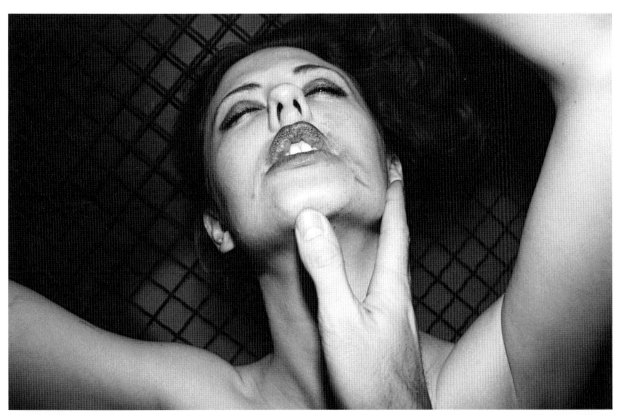

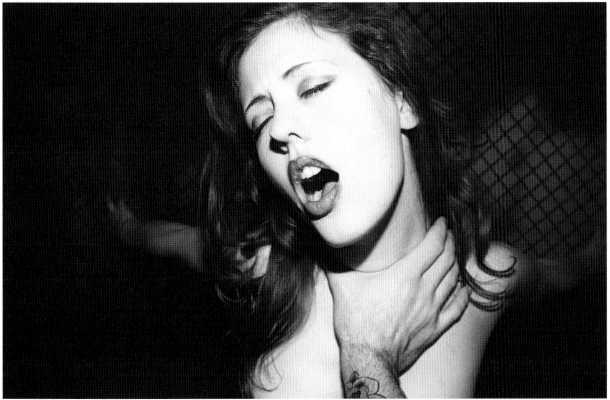

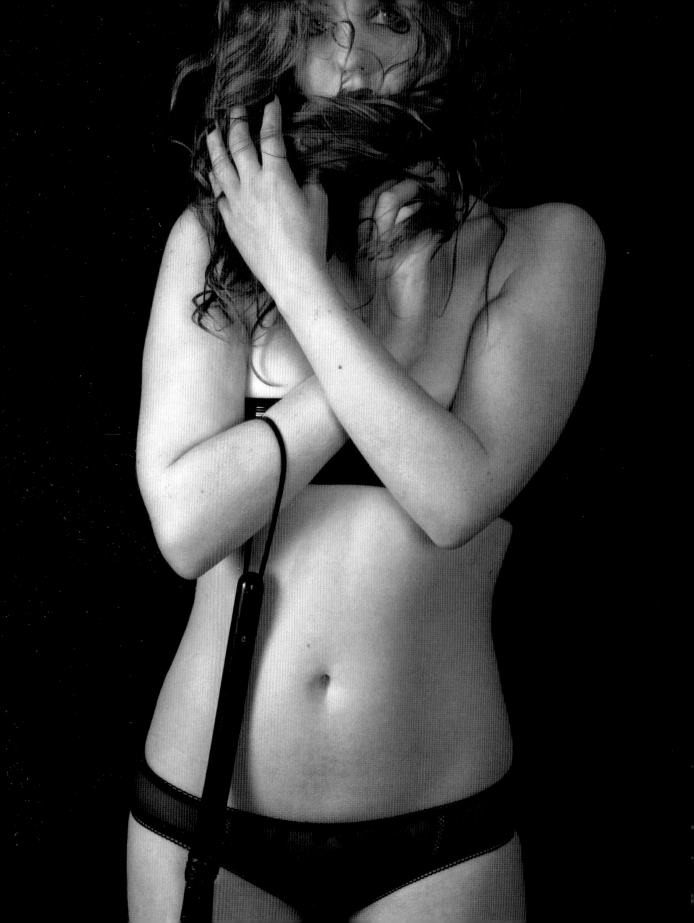

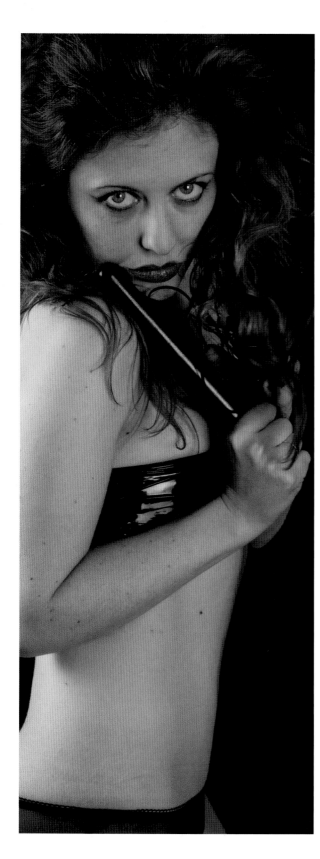

Preparation

Preparation can be enjoyable for both of you. Try sucking, licking, pinching and soft biting beforehand. The nipples should be hard and stiff before clamping.

Ready to play?
- Open the clamp to its fullest.
- Gently apply the clamp when the nipples are hard and erect.
- Adjust the tension to the get the desired sensation.
- If it's not too much, try and get used to the feeling. Always communicate with your partner. You must let him/her know what feels pleasurable and what hurts.
- Only use them for few minutes at a time.

Feeling adventurous?

Using nipple clamps with a chain can be fun. Either partner can play tugging or pulling on the chain, increasing the pressure on the nipples.

Removal

The most pain caused by clamping is actually when the clamps are removed. The main thing to remember is that clamping cuts off the circulation to the nipple so when the clamps are removed there is a rush of blood back to the nipples. This can be the most painful part.

Remove them very slowly and exhale when the clamp is released. It can help if the nipples are very gently sucked and licked immediately after.

Temperature play
Hot wax
When used safely, candles can be great fun.
- Test the temperature on your own skin first.
- Try pouring the wax high above your sub, and then gradually bring it closer to the skin. The greater the distance between

the skin and the candle, the cooler the wax will be. This enables you to see which temperature is comfortable for your sub.

– For extra safety, blow the candles out before pouring the wax, but be quick before it all hardens again!

Ice

Playing with ice cubes can be an interesting sensation, especially when combined with hot wax. Leave the ice cube at room temperature before any ice play. Ice lollipops can also be great fun, but try no to get carried away and get frostbite!

Remember that communication is key, and if something is too hard for you, then use the "safe word." That's what it's there for!

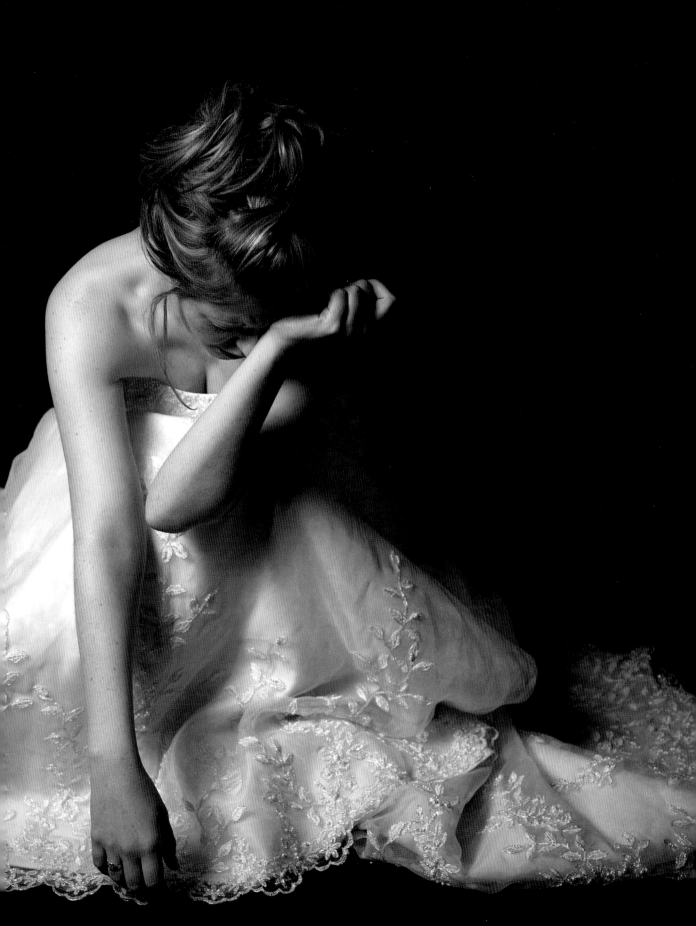

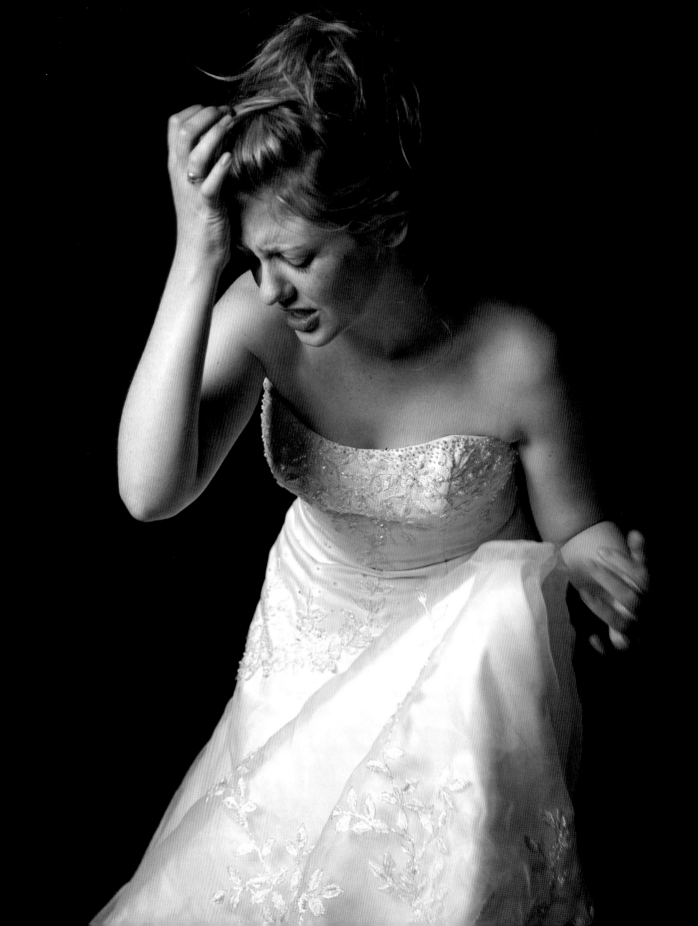

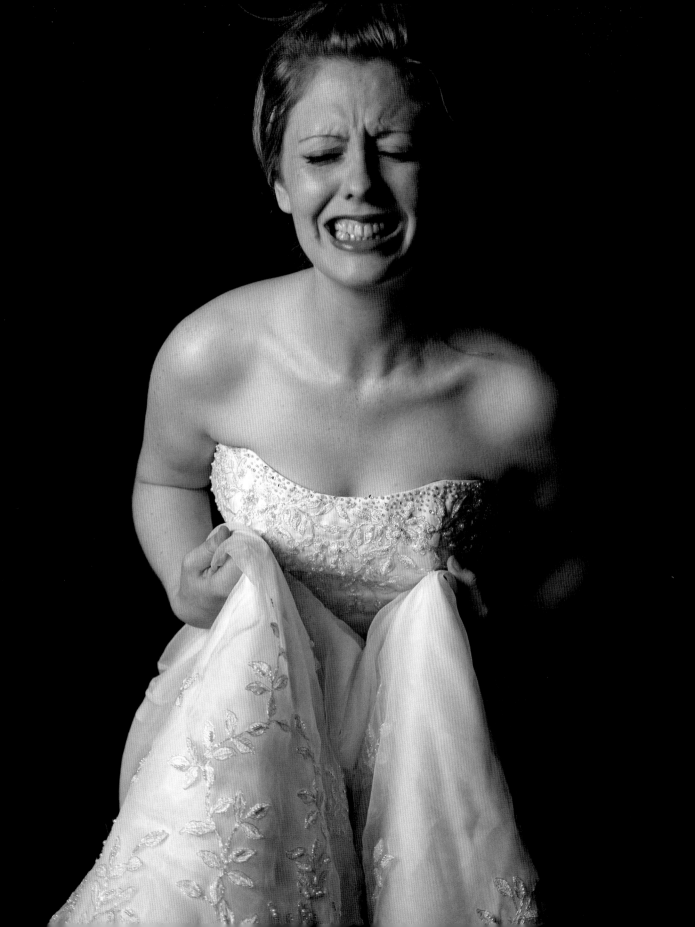

>>> Pain confession: a naughty schoolgirl gets her shocking spelling mistakes sorted out once and for all

Private lessons
"Teacher looking for naughty schoolgirl for individual tuition"
An excited tingle began between my thighs. This ad looked, and felt, highly promising. *"You will come to my school with a short pleated skirt and white schoolgirl knickers. Whenever you misbehave you will have to bend over your desk for a good spanking."* I typed my reply and clicked on the send button without pausing for a breath. *"ive scene yor ad anned maybee yu kud helpp mee with mye spanish. Ime a gud student butt az yu kan sea, I make alott ov misstakes. Ime inglish anned iff yor kultivatid yu wil no howe muchh wee lyke dissiplin."* The next day, when I logged on, I saw the reply waiting for me. *"Mmm so let's see what we can do with your Spanish. Yes, I do know how to use discipline, and I am a strict teacher. I hope you are a good student too. Send me your mobile and I'll call you soon."*
My response had been waiting in my mind for days:
"deer teacher inn mye kuntry, thay saye thatt yu shud neva giv yor telefoan numba two strangas. They allso saye thatt yu shudnt acsept sweetes or invitashons two sea knewborn pupeez. Cud yu tel mee mor abbout yorself bephorehand? Ayge phor exxample. All so, howe kan I bee shure thatt yor reallee kwalified? Yor schoodent."
In reply:
"Dear student, hahha don't be afraid. I'm a qualified teacher and I'm 37. The perfect age for a teacher. How old are you? I wont offer you sweets but I might bring you a lollipop. Send me a photo so I know you're not joking.
Teacher"

"Dere Teacher,
Ime knot joeking att all, butt Ime knot goin two senned yu eny fotos. The onlee thiing yu kneed two knowe iz thatt Ime atractiv. Ime 27 anned sum wud saye thats a littul olde phor ah skoolgirl butt I saye, its neva too layt two lern.
Yor stoodent."
My poor grammar and spelling became more and more provocative to him and, one day, I noticed a difference in his online demeanour:
"I don't know if we'll ever have sex, but we will surely have a few laughs together. You're probably a dirty old man and no schoolgirl."
I read the message at my desk, while the men in the office drifting by and wondered about my underwear. My instincts reassured me of my "teacher's" veracity; I emailed him my telephone number.
"Call me this night you see I am no man!"
I had sent him faceless images of myself, but he didn't believe that it was me. That evening I was on the sofa, bored by a TV programme about celebrities when my mobile throbbed with "private number" flashing on the screen with uncharacteristic urgency.
"Hello?", I answered
"Ah, so you are a girl after all", the voice exclaimed.
He gave me the well-rehearsed, history of his life, with anecdotes to illustrate his finer points of character. He was interesting, intelligent and well-travelled. We

didn't need to mention sex at all. I ticked another mental check-box and I decided to take a risk.

"Come round for dinner at my place, tonight or never", I stated. I read out my address and ended the call with my pulse echoing loudly in my head. I was going to be the schoolgirl and dinner would be a private class. I assumed the lack of poise, the rebelliousness and the allure of my remembered schoolgirl persona: white blouse, pleated mini-skirt, knee-length socks, ballerina pumps and of course, pigtails. I decided not to cook a meal and prepared some plates of colorful snacks on the table. The doorbell rang and my heart found a tribal rhythm like hard hands on skin-covered drums. I opened the door, discreetly, not wanting to risk any of my neighbours seeing me.

"Oh my God!", he breathed when he saw me for the first time.

"Hello, teacher. Are you prepared for the lesson?"

He coiled backwards as if stung, not wanting to succumb too soon.

"Come here now!", I challenged his weakness.

He entered my flat and followed me into the lounge staring at my derriere. He never registered that there was only school-standard cuisine on offer. Seduced by the promise of my uniform and worried about how I was going to engineer his torment, he was distracted beyond reason. We sat down at the table, drank wine and ate crisps in silence. He stared at me as we endured awkward small talk. I felt that the lesson wasn't proceeding as it should so I opened my legs, wide. He stared down at my waxed sex and words became redundant.

"What's wrong, teacher? Am I a bad student?", I inquired.

"You're the worst I've seen in my whole career." He trembled as the words fell from his lips.

"What am I doing wrong?", I asked again, sucking my thumb.

"You're fucking with my mind, aren't you?", he asked.

"Clearly", I agreed.

"What did you say, girl?" He improvised, reminding me of the obvious next step.

"Yes, sir!", I permitted.

"I've had more than enough of your insolence!", he shouted. "Lean over the table!"

I was bristling with excitement as I got up, did as he said and closed my eyes.

"Playing with the mind of your teacher is forbidden in this place!", he railed.

"Yes, sir", I conceded in a low voice.

He lifted my skirt and I tensed my body in anticipation. Time seemed to halt in the space between us and a chill caressed the whiteness of my thighs. The perfection of his pause stretched out like a lifetime. It ceased, suddenly, when his hand hit my pliant buttock. His spanking was undisciplined and tentative at first, but began to assume a vehemence and enthusiasm that allowed the beads of moisture to gather and bubble from my rebellious sex.

"You're trying to play with my mind, aren't you?", he restated with each stroke.

"Yes", I whimpered as a response to each of his measured slaps.

My skin burned and I imagined my lacerated bottom in perfect detail, needing a pause.

"No", I pleaded. "I don't want to play with your mind!"

He awoke from his fever dream, stopped the spanking, trembled and wavered on unsteady feet. We moved apart and sat down, again, in silence. We poured more

wine, and after a few moments I realized that I didn't like my music selection at all. I went to my computer to change it, oblivious to the position I assumed as I bent over it. I felt animal breath against my sore cheeks, and then his probing tongue. He knelt behind me and I bent forward, permitting him free access. His spiraling tongue was so soft and delicate that the raw contrast between its tenderness and the corporal punishment earlier set up a rich contradiction in my desires. I felt constrained in the position so I ordered him to stop, and I stood up straight, neglecting to adjust my skirt. I made my way back to the table and sat down. The teacher followed me in silence. The "class" continued and he repeated his conviction that I was an appalling student. When the dialogue became exhausted, I opened my thighs in front of him, again. Sometimes he would spank me with his new-found confidence and other times he would go down on me and stir my juices with his clever tongue. The pressure of this intensive repetition of punishment and reward became too much to bear. The preliminaries were over. I had reached the plateau and only needed to be urged over the edge into ecstasy.

"Teacher, don't you see? I really don't get it", I said.

"Explain yourself, girl?", he demanded.

"I just feel that I need something harder to, you know, really learn my lesson."

"Continue", He sneered.

"I need a whipping", I stated.

"Where is the whip kept in this room, then?", he inquired.

"No, *your* whip", I explained.

I indicated his erection.

"Your man-whip", I elaborated.

I had assumed the real power and he was adrift in my personal space. I maintained a strict formality in my actions as I gathered a blindfold and leaned across the sofa.

"You know, teacher, I've never seen a real man-whip before, and I certainly wouldn't want to see yours when it was being applied." I blindfolded myself and waited. I felt the displacement of air behind me and he penetrated me slowly. My mind was abstracted from the moment, and he increased the urgent force and mindless rhythm of his thrusts. The build-up to this moment had been months in the making and I felt in the stiffening of my thighs that the final moment was near. It concluded abruptly, like a parenthesis, leaving me dizzy, shocked and disoriented.

After exchanging some awkward pleasantries at the table, he left. We were both in shock at the perfection of that brief but unrepeatable instant. With perfect punctuation, grammar and sentence structure, I composed an email a week later and

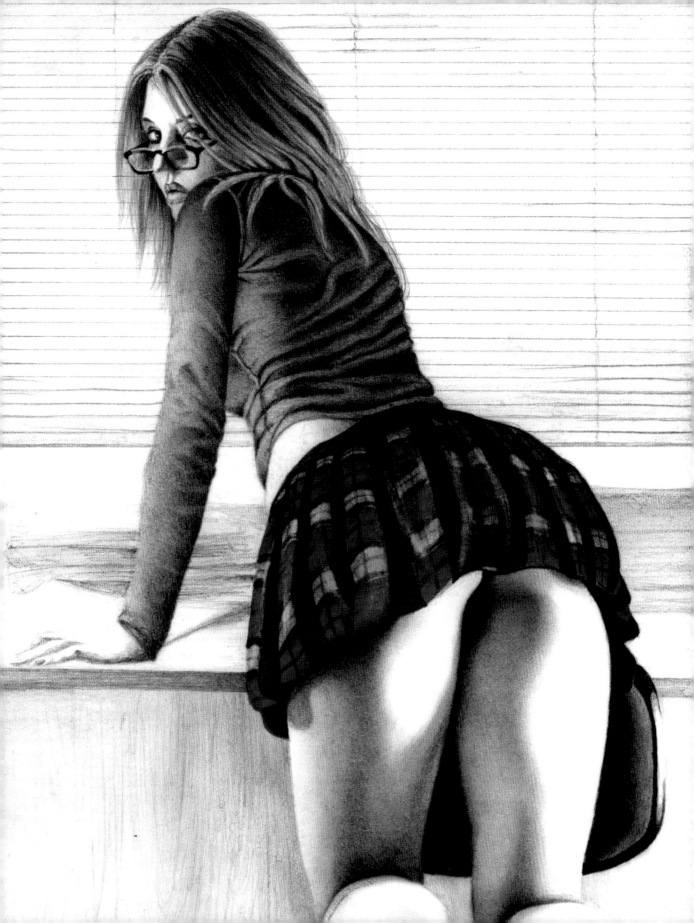

>>> Revenge can be very sweet
>>> Annoying things
>>> Revenge confession

REVENGE

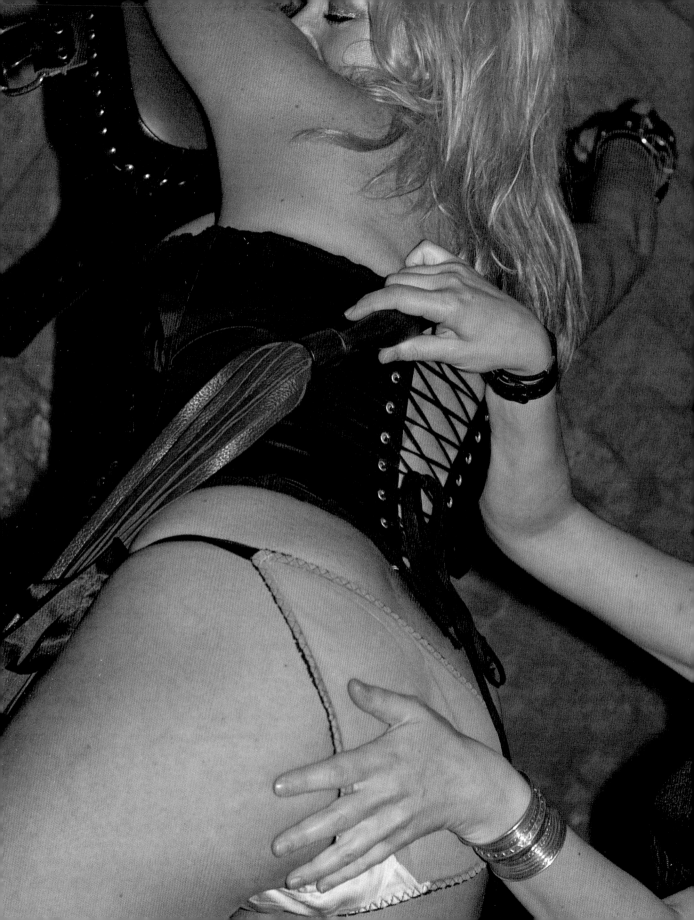

>>> >>> Revenge can be very sweet

Switch revenge

For "switches," the subject of revenge is clear. You may remember a scenario where you have been submissive and want to get your own back when the roles are reversed. What annoys you? Most relationships have underlying issues that raise their ugly heads from time to time. Maybe you don't like your in-laws, or he is still friends with his horrible ex? Does he spend too much time in the pub or is he untidy? Does he leave the toilet seat up all the time? Whatever the issue is in your relationship, why not convert the negative into something positive and exciting?

>>> Annoying things

PROBLEM: He drools over other women in front of you...
POSSIBLE SOLUTION: Next time a good looking guy appears in the television say "phwoar!" and start to touch yourself. Your boyfriend should get the message.

PROBLEM: He often arrives late.
POSSIBLE SOLUTION: People do what they can get away with, so if he's late and you wait, he will probably arrive late on other occasions. It's simple. Do not wait! Leave after ten minutes, and when he sees you've not waited around, he should make a special effort to be on time for your next rendezvous. Don't forget to reward him if he arrives on time.

PROBLEM: He doesn't pull his weight at home.
POSSIBLE SOLUTION: Messiness can be the cause of arguments in many relationships. Sexual deprivation could be a good way to get back at a messy lover.

PROBLEM: He is a flirt.
POSSIBLE SOLUTION: Next time you go out with his friends, wear a top that exposes your killer cleavage and try to engage in conversation with his friends. It will be difficult for the friends to look you in the eye, and this should drive him mad!

PROBLEM: He called you by the wrong name.
POSSIBLE SOLUTION: This isn't good. Do the same back at a "key" moment.

PROBLEM: He spends too much time in the pub.
POSSIBLE SOLUTION: Organise a wild girls' night out and DO NOT check your phone every five minutes. Try to enjoy yourself and lose track of time.

PROBLEM: He monopolizes the remote control.
POSSIBLE SOLUTION: Hide it and demand sexual favours when he asks you where it is.

PROBLEM: He rarely goes down on you but demands oral sex.
POSSIBLE SOLUTION: Refuse to go down on him until you achieve equality.

PROBLEM: He wants you to wax and you don't want to.
POSSIBLE SOLUTION: The subject of body hair is very personal. If you don't want to, try waxing part of his legs to see how he likes it.

PROBLEM: He wants to have a threesome with your best friend.
POSSIBLE SOLUTION: Suggest a threesome with another male and see how he reacts.

PROBLEM: He says you're fat.
POSSIBLE SOLUTION: Point out all his physical flaws. If this doesn't work, then you should try and find someone else who will love your curves.

WARNING!: Don't forget it's supposed to be about fun and try not to create further issues in your relationship when handing out "revenge."

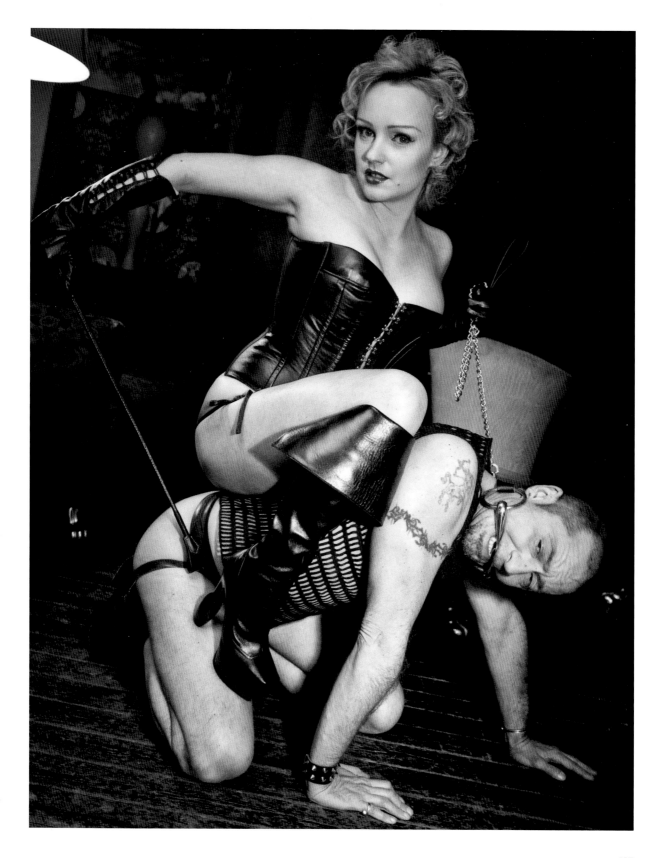

>>> Revenge confession: the following confession is from a woman who was sick of her partner teasing her about her weight. He was, of course, nothing special himself...

Wax

There is only a little beauty to be found in a hairy man's back. You can shave it, pluck it or depilate it in any way you wish, but the sprouting bristles will confound you every time with their almost mechanical predictability. Before you know it, the arrogant hairs will spite you with their urgent growth, for they seem to have infinite reserves of ugliness lurking below the surface to draw from.

I imagined my boyfriend's un-waxed back, sweating beneath his shirt as he raised the magic eyebrow before continuing with his lecture about my primary imperfection. He had been stuck on the same morsel of criticism all day, and I was beginning to buckle under the constant pressure of his remorseless chewing upon it.

Every minor niggle, major disappointment and insurmountable summit that had oppressed him, in the whole dismal duration of his life, boiled down to one unforgiveable symbol that blazed in his face constantly: my shapely hips. I have always been obliged, by boyfriends, lovers and other fellow travellers to be self-conscious about the surplus of curves where my hips are concerned. As a comic diversion, I have always put their shape down to an unwanted hereditary heirloom from an opulent courtesan somewhere in my disreputable family's distant past. I imagined her being feted and cherished by Rubens for her idealisation of the womanly principle; neither could he fail to mention her glorious curly hair as it hung down to her nipples or her diminutive shoulders as he whispered his devotion to her.

Some people expressed their admiration, attraction and arousal towards my generous curves but, by this point, I had become so programmed by society's ambivalence towards renaissance perfections in that area that I never found those opinions remotely credible.

So, on this particular evening, after he had run through his usual menu of listless comments without really hitting my sore spot, he was a little annoyed. I was giving my undivided attention to the handful of my framed life-drawings that decorated the walls so I wasn't aware that his preferred insult was bound to feature next. As I swayed from side to side with the remembrance of the art classes from whence my drawings originated, he sidled up, turned me around slightly to face him, smiled a lop-sided smile and pinched the skin over my hips; pinched quite hard. He proceeded to roll and knead my tender flesh like a piece of meat on a cutting board and giggled like a nine-year-old with each abrupt invasion.

"Can't you do something about this extra wide load?", he wondered. "Perhaps you should employ a pair of motorcycle outriders to flank you when you're walking along the street?"

I turned my face away from him then and found my gaze fixed on a photograph of the two of us that sat on an adjacent dresser. I looked into the image that we presented to the world as a couple and I found that we had always come up short. I looked benign, not unhappy exactly but worryingly placid. He gave the impression,

...in the picture, or setting not just for second best but for fourth or fifth best.

"Did you hear me?", he demanded as he squeezed me again. "How about flashing lights and sirens, as well, to let them know that you're coming?" That was all that it took. The room flashed around me, my cheeks fired red, and I found my limit with his smooth persecutions.

"Do you want to play a game, big man?" I trembled as I whispered it. "For someone as perfect as you so clearly are, it should be simple." His masculine pride glowed in his smoking eyes like busy embers and he nodded at once; even going so far as to flex the absence of muscle in his soggy chest.

"Close those pretty eyes", I demanded, softly. He did so with a smirk. Using the stereo remote control to raise the volume of the ambient music, I used his momentary disorientation to retrieve the blindfold I kept hidden and made a point of placing it over his eyes with more force than was entirely necessary. I turned the television on, raised its volume and returned to the pitiful figure he presented in the middle of the lounge. Without further ado, I spun him round four or five times before I led him careening from left to right, towards the rigid dining table chair that I had set aside. He grunted like a sick pig when I pushed him down onto the chair the wrong way round, so his chest impacted on it's ornate back support. He was barely aware of the short lengths of clothes line that I used to secure his sweaty wrists and bristly ankles to the rigid wooden supports of the unforgiving piece of furniture.

It was time to cool down a little before the next stage. It was better to enjoy my vindictive thrills with cold blood in my eager veins. As I backed away, it came as a revelation to see his expanse of deltoid and trapezius splayed out before my indifferent gaze. He was just a piece of bound meat after all: hairy, bound, meat. A silverback gorilla, at prayer, seemed like the closest comparison I could draw as I regarded the oily hairs that covered the sallow, loose, wattles of skin. In some places, the hairs were as thick and glossy as curls of stripped fuse-wire. This could not stand. This vista provided a perfect field to resolve this battle between competing notions of achievable beauty. It was with this in mind that I slipped my shoes off and tiptoed to my other hiding place to fetch the cardboard packet that nestled there. He was getting nervous. I could smell the perspiration changing from tolerable to frankly objectionable. I let him wait a few minutes longer. Then, he winced as I placed a wax strip on the hairiest part of one shoulder in a smooth move that resembled a slow-motion slap of interventionist correction. Lifting my hand away from the secured strip, so similar to a vast corn-plaster in the pulsing half-light, I leaned in to his right ear and purred a few words.

"You know, Hun, I'm so sick and tired of you saying that I always look so bad that I can hardly tell you. Don't forget the biblical injunction: Let He who is without sin cast the first stone, or in this case...pull the first tuft." Plas!

The strip tore a raw rectangle of curls away from his skin when I pulled it away. Plas! Now there were white, small-gauge railway tracks amongst the dark foliage.

He tried to move, but I had done my online research into knots with diligence.

I continued on and on, until the empty packet fell to the floor.

The irregular and asymmetrical anatomy of his back was clear to me, now that it was red, naked and raw. I couldn't take the odd assortment of fat, muscle and loose skin as anything other than an insult to the smooth lines of my hips. They were separate expressions of physicality, but his was flawed, unruly and ugly to my eyes. It reminded me of a grossly enlarged chin, freshly shaved and glowing with pink

ness. It needed cologne to close the animal pores. I twisted the glass bottle open and poured the clear liquid onto my free hand. Placing the bottle on the kitchen table, I rubbed the wetness on both of my pliant hands before I slapped his back all over with them. He realized it was surgical spirit an instant before his nerves shouted the fact into his brain with a megaphone.

It was only later when I freed him that I complimented myself, loudly, on a good job, done exceedingly well. Abashed, self-pitying and morose, he went into a profound sulk which was hardly attractive. With a lop-sided grin I sought to reassure him: "It's a little red, to be sure, but tomorrow…that's when it really will sting." I took more than a moment to regard the photograph of us again, and frowned. I couldn't wipe the smile off of my face for days. In fact, I smile about it even now as I take my new lover for his walk around the house. I met him at an exhibition of contemporary nude painting and photography when I noticed him staring at my body with undisguised reverence. He was one of the exhibited photographers whose work I was admiring at that very moment. I had noticed a predilection in his work for opulent hips and small shoulders and, over coffee, he went into more detail about how enraptured he was with the realization of his desires that I, alone, represented. He oozed credibility. I was convinced from the start. That was a month ago and now I was living with him as his literal muse. He drew me, painted me and photographed me relentlessly. Sometimes he forgot to eat properly, so I had to step on his neck and push his face into his dog bowl to remind him. Today, as I drag him around by his lead, I notice that a few tell-tale hints of stubble are beginning to appear between my doggies shoulder blades. My secret stash of special strips begin to beckon, but I will let it go for now. There is only a little beauty to be found in a hairy man's back, but there is no small virtue to be had from the fur of an obedient dog.

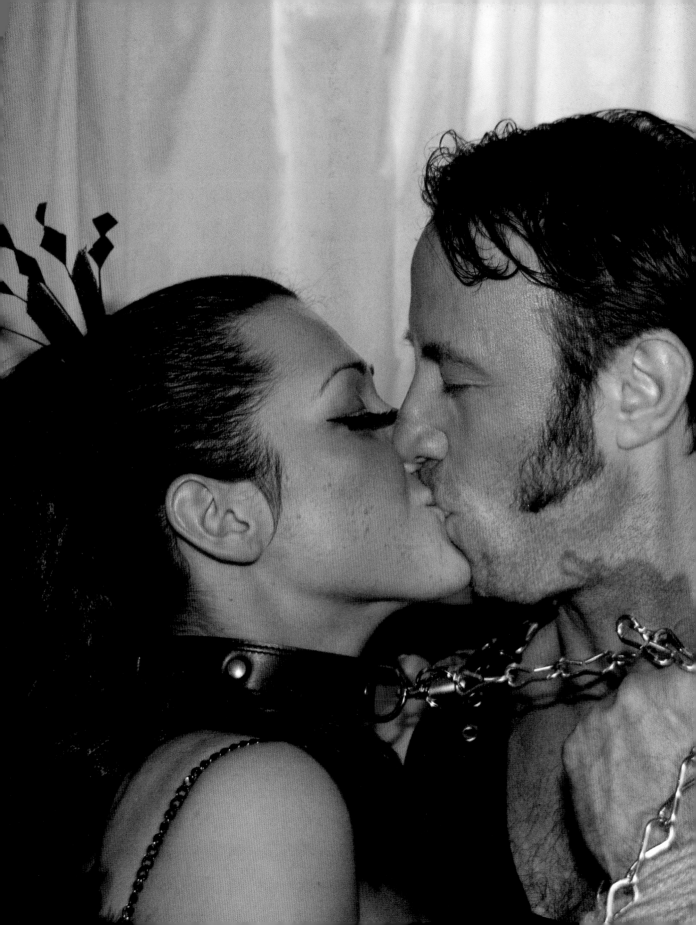

>>> Films and literature
>>> Literature
>>> Comics
>>> Films

FILMS AND LITERATURE

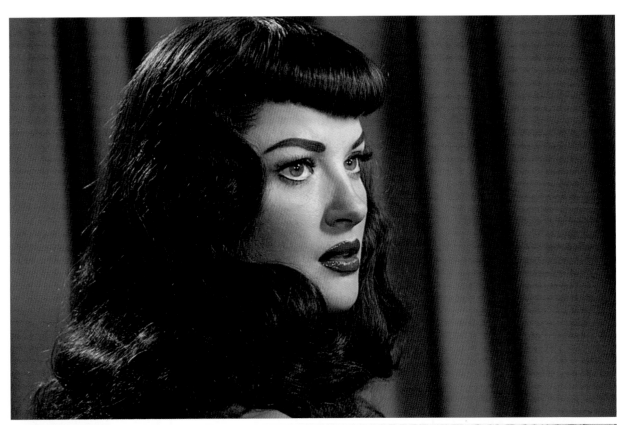

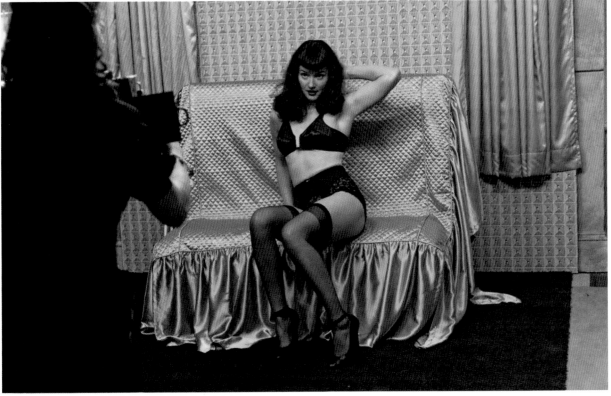

>>> Films and literature

When you begin to explore a new realm like the one we are introducing you to in *Love Me Like You Hate Me*, it can be insightful to exploit inspirational resources in popular cinema and classic literature. The easiest way to appreciate how pain can be synonymous with pleasure, how domination and submission can be the ultimate expression of love and how spanking can heighten and refine the erotic response is to read intelligent narratives or watch sophisticated films that relate these experiences. Here we shall recommend some of the best books and films from the last few years. Some are classics and some are more contemporary, but they are all instructive.

>>> Literature

Histoire d'O
Story of O (French: *Histoire d'O*) is an erotic novel published in 1954 about dominance and submission by French author Anne Desclos under the pen name Pauline Réage. *Story of O* is about a beautiful Parisian fashion photographer, O, who is blindfolded, chained, whipped, branded, pierced, made to wear a mask, and taught to be constantly available for sexual favours. Despite her harsh treatment, O grants permission beforehand for everything that occurs, and her permission is consistently sought. In 1975 the novel was adapted to a film directed by Just Jaeckin and starring Corinne Clery and Udo Kier. It was banned in the United Kingdom by the British Board of Film Censors until February 2000.

Anne Rice's *Exit to Eden* and *Sleeping Beauty* trilogy
The Claiming of Sleeping Beauty (1983), *Beauty's Punishment* (1984), and *Beauty's Release* (1985) are erotic novels by Anne Rice writing under the pseudonym of A. N. Roquelaure. The novels are reminiscent of *Story of O*, set in a medieval fantasy world

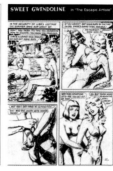

based very loosely on the legend of Sleeping Beauty. The novels contain both maledom and femdom scenarios, as well as vivid imageries of bisexuality, ephebophilia and bestiality. Beauty is awakened from her hundred-year sleep by the Prince, not with a simple kiss, but with a deflowering, initiating her into a Satyricon-like world of sexual adventures. After stripping her naked, he takes her to his kingdom, ruled by his mother, the Queen, where Beauty is trained as a slave and a plaything.

Laura Antoniou's *The Marketplace* series

Laura Antoniou (born 1963) is an American novelist. She is most famous as the author of *The Marketplace* series of BDSM-themed novels, which were originally published under the pseudonym of Sara Adamson. Laura Antoniou has also published many other books including the three *Leatherwomen* anthologies.

>>> Comics

Eric Stanton

Eric Stanton (1926-1999) was a comic artist from New York. He began drawing for Irving Klaw in 1947. At first he drew fighting women and later bondage serials. Much of his work features female domination scenarios.

John Willie's Sweet Gwendoline

Sweet Gwendoline is the main female character in the works of bondage artist John Willie, published in magazines in the 1950s and 1960s. She was possibly the most famous bondage icon after Bettie Page.

In Willie's drawings, Gwendoline appears as a rather naive blonde damsel in distress with ample curves, who is unfortunate enough to find herself tied up in scene after scene.

At the end of the 1950s Willie published a 64-page comic book called *Sweet Gwendoline*.

>>> Films

The following is a rough guide to BDSM cinema that you might find highly instructive but with only enough detail to arouse your curiosity.

Belle de Jour by Luis Buñuel (France, 1967)

Belle de Jour is a film based on a novel of the same name written by Joseph Kessel. *Belle de Jour* expertly dramatises the collision between depravity and elegance, fantasy and reality, one of the favourite themes of director Luis Buñuel. Séverine Serizy (Catherine Deneuve) is a young, beautiful housewife who has masochistic fantasies about elaborate floggings and bondage. She is married to a doctor (Jean Sorel) and loves him, but cannot share physical intimacy with him. Early in the film we see Séverine getting tied to a tree and whipped, which turns out to be only a daydream; in reality, Séverine and her husband sleep in separate beds. A male friend, Monsieur Husson (Michel Piccoli), mentions a high-class brothel to Séverine, also confessing his desire for her. She becomes intrigued and starts to work at the brothel during the afternoon. Séverine only works until 5 pm, returning to her husband, who is completely unaware. *Belle de Jour* is a hypnotic and erotic masterpiece.

9 1/2 Weeks by Adrian Lyne (USA, 1986)

9 1/2 Weeks is an erotic drama directed by Adrian Lyne and starring Mickey Rourke and Kim Basinger. The film is based on the novel of the same title by Elizabeth McNeill. The film is now well known for its erotic sadomasochistic content. The film has two sequels: *Another 9 1/2 Weeks* (1997) and *The First 9 1/2 Weeks* (1998). The title of the film refers to the duration of a relationship between Wall Street arbitrageur John Grey and divorced SoHo art gallery employee Elizabeth McGraw. The two meet and conduct a volatile and sometimes obsessive sex life. The film features a sexual downward spiral as John pushes Elizabeth's boundaries toward her eventual emotional breakdown.

Elizabeth (Academy Award® winner* Kim Basinger) is a Soho gallery worker, romantically uninvolved since a painful divorce. John (Mickey Rourke) is a wealthy commodities broker, emotionally alone no matter who he's with. A chance meeting draws them into each other's worlds. Obsession takes them further into a mutual world of eroticism and emotional awakenings.

With visual flair, director Adrian Lyne (Fatal Attraction, 1998's Lolita) explores extremes of passion and surrender in 9½ Weeks, presented in an expanded version with footage not seen in U.S. theatrical release. Passion fades. But something John and Elizabeth will always carry inside is the impact of their 9½ Weeks.

SPECIAL FEATURES: Interactive Menus · Theatrical Trailer · Scene Access · Languages: English & Français · Subtitles: English, Français & Español. Access them by pressing the MENU key on your DVD player remote control. Press the MENU key again to return to the movie.

PRODUCERS SALES ORGANIZATION AND SIDNEY KIMMEL PRESENT A KEITH BARISH PRODUCTION AN ADRIAN LYNE FILM MICKEY ROURKE KIM BASINGER "9½ WEEKS" MUSIC BY JACK NITZSCHE BASED ON THE NOVEL BY ELIZABETH McNEILL SCREENPLAY BY PATRICIA KNOP & ZALMAN KING AND SARAH KERNOCHAN EXECUTIVE PRODUCERS KEITH BARISH AND FRANK KONIGSBERG PRODUCED BY ANTHONY RUFUS ISAACS AND ZALMAN KING DIRECTED BY ADRIAN LYNE FROM JONESFILM IN ASSOCIATION WITH GALACTIC FILMS AND TRIPLE AJAXXX A PSO RELEASE

NOT RATED Color/118 Mins.

Mickey Rourke Kim Basinger

9½ Weeks

65054

ORIGINAL UNCUT, UNCENSORED VERSION!

ISBN 0-7907-4391-4

Elizabeth (Academy Award® winner* Kim Basinger) is a Soho gallery worker, romantically uninvolved since a painful divorce. John (Mickey Rourke) is a wealthy commodities broker, emotionally alone no matter who he's with. A chance meeting draws them into each other's worlds. Obsession takes them further into a mutual world of eroticism and emotional awakenings.

With visual flair, director Adrian Lyne (Fatal Attraction, 1998's Lolita) explores extremes of passion and surrender in 9½ Weeks, presented in an expanded version with footage not seen in U.S. theatrical release. Passion fades. But something John and Elizabeth will always carry inside is the impact of their 9½ Weeks.

SPECIAL FEATURES: Interactive Menus · Theatrical Trailer · Scene Access · Languages: English & Français · Subtitles: English, Français & Español. Access them by pressing the MENU key on your DVD player remote control. Press the MENU key again to return to the movie.

PRODUCERS SALES ORGANIZATION AND SIDNEY KIMMEL PRESENT A KEITH BARISH PRODUCTION AN ADRIAN LYNE FILM MICKEY ROURKE KIM BASINGER "9½ WEEKS" MUSIC BY JACK NITZSCHE BASED ON THE NOVEL BY ELIZABETH McNEILL SCREENPLAY BY PATRICIA KNOP & ZALMAN KING AND SARAH KERNOCHAN EXECUTIVE PRODUCERS KEITH BARISH AND FRANK KONIGSBERG PRODUCED BY ANTHONY RUFUS ISAACS AND ZALMAN KING DIRECTED BY ADRIAN LYNE FROM JONESFILM IN ASSOCIATION WITH GALACTIC FILMS AND TRIPLE AJAXXX A PSO RELEASE

NOT RATED Color/118 Mins.

KIM BASINGER
MICKEY ROURKE

THEY BROKE EVERY RULE

9½ Weeks

65054

ISBN 0-7907-4391-4

Bitter Moon by Roman Polanski (France-UK-USA, 1992)

Bitter Moon was directed by Roman Polanski and stars Hugh Grant, Kristin Scott Thomas, Emmanuelle Seigner and Peter Coyote. A British couple – Fiona (Scott Thomas) and Nigel Dobson (Grant) – are sailing to Istanbul en route to India. They meet a highly unconventional couple, American unpublished would-be literary celebrity Oscar (Coyote), in a wheelchair, and his much younger Parisian wife Mimi (Seigner). While living in Paris for several years trying to be a writer, Oscar became obsessed with Mimi, who he met by chance on a bus. He tracked her down and they started a steamy love affair. Oscar insists on telling his unsettling life story in explicit details to Nigel. Oscar recounts how his and Mimi's love developed and took a dark turn. They explored bondage, sadomasochism and voyeurism. Initially Nigel is to polite to refuse and is often disgusted, but he soon becomes fascinated.

Venus in Furs by Victor Nieuwenhuijs (Netherlands, 1995)

The most recent adaptation of *Venus in Furs* was directed by Victor Nieuwenhuijs. The film was shot in black and white and is an excellent adaptation of the book. Julia Braams stars as Wanda and André Arend van de Noord as Severin.

Quills by Philip Kaufman (UK, 2000)

Quills is a period drama which is inspired by the life and work of the Marquis de Sade, set in the insane asylum of Charenton, where he spent the last years of is life. The film was directed by Philip Kaufman and is based on an award-winning play by Doug Wright. The film stars Kate Winslet, Geoffrey Rush, Joaquin Phoenix and Michael Caine.

The Piano Teacher by Michael Haneke (Austria-France-Germany, 2001)

The Piano Teacher (French: *La Pianiste*) is a 2001 film directed by Michael Haneke, starring Isabelle Huppert and Benoît Magimel. Erika is a piano teacher at a prestigious music school in Vienna. Although she is in her forties, she still lives in an apartment with her domineering mother (Annie Girardot). Lonely and alienated, Erika finds solace by visiting sex shops and experimenting with masochism.

At a recital, she befriends Walter (Benoît Magimel), a handsome young man, whom she seduces and begins an illicit affair with. As Erika slowly drifts closer to the brink of emotional disorder, she uses the love-stricken Walter to explore her darkest sadomasochistic fantasies. However, Walter is unwilling to indulge her violent fantasies, which repulse him.

Secretary by Steven Shainberg (USA, 2002)

Secretary is a 2002 sadomasochism-themed film directed by Steven Shainberg, starring Maggie Gyllenhaal as Lee Holloway and James Spader as E. Edward Grey. The film is based on a short story from *Bad Behavior* by Mary Gaitskill. Lee Holloway is adjusting to normal life after spending some time in an institution following an accident of self-harm. Although she's never had a job in her life, Lee is hired by E. Edward Grey, an eccentric lawyer who seems unconcerned by her lack of experience, limited social skills and unprofessional appearance. Although the work is relatively simple and boring, Lee often makes silly mistakes despite trying hard to please her boss. At first, Grey appears to be highly irritated at Lee's typing errors and clumsiness. However, he soon becomes sexually aroused by her submissive behavior. One day he confronts her about her self-harm and he orders her never to hurt herself again. Lee experiences a sexual and personal awakening and falls deeply in love. Edward, however, feels ashamed and disgusted over his sexual habits and has trouble coming to terms with his feelings for Lee.

The Notorious Bettie Page by Mary Harron (USA, 2005)

The Notorious Bettie Page from 2005 was directed by Mary Harron. The film recounts the life of 1950s pin-up and bondage model Bettie Page. Gretchen Moll stars as Bettie. Following a childhood of sexual abuse, a failed marriage and a gang rape, Bettie longs to leave Nashville, Tennessee. In 1949

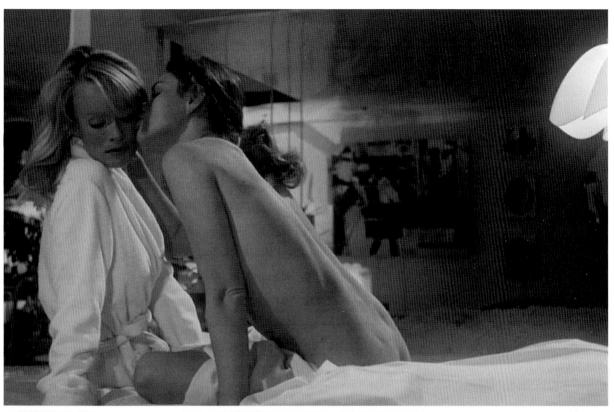

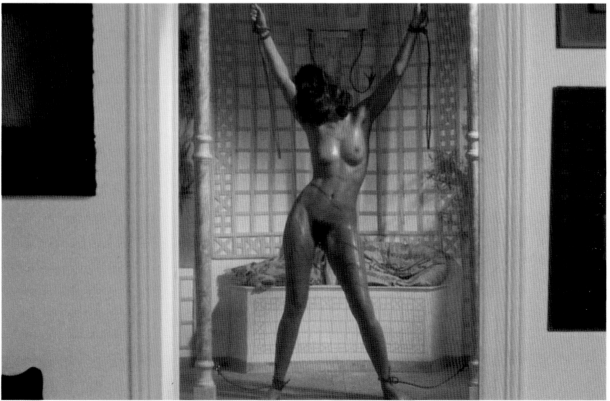

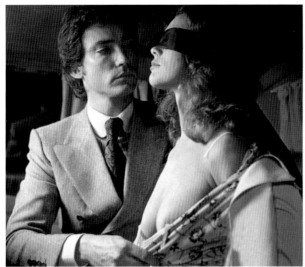

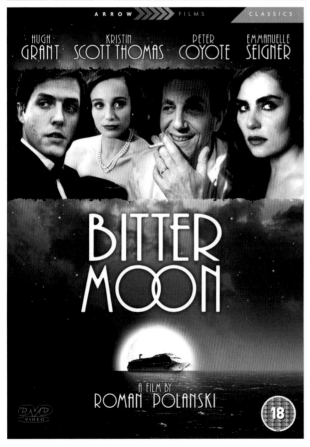

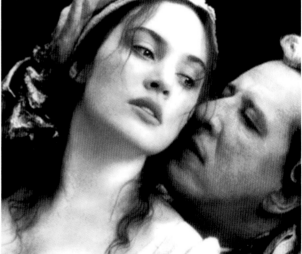

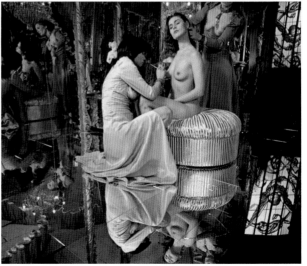

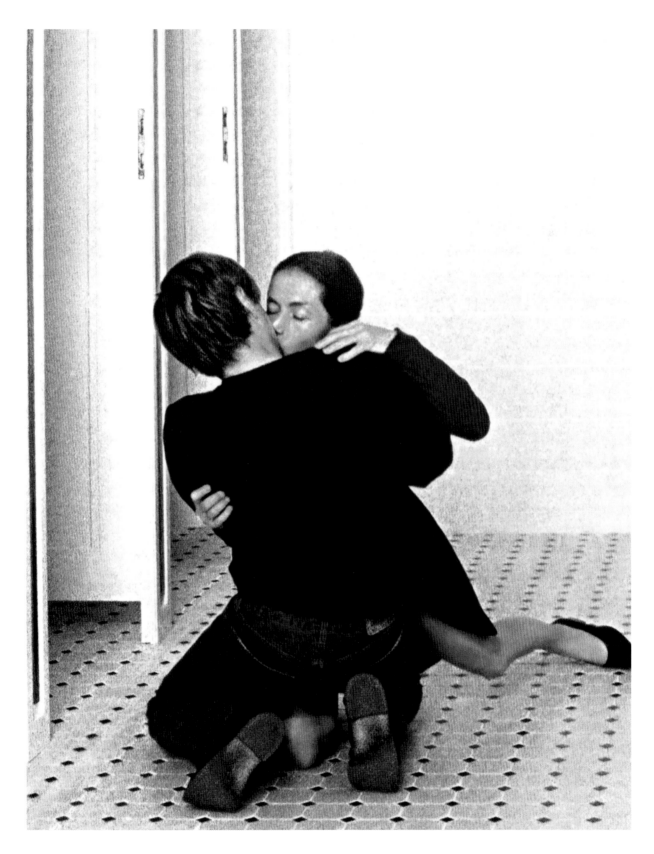

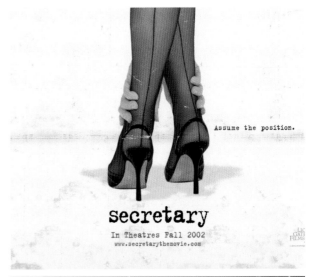

she goes to New York City, where she enrols in an acting class. One day while walking on the beach at Coney Island, she is discovered by amateur photographer Jerry Tibbs and she agrees to model for him. He suggests that she should cut a fringe that would become her trademark. Bettie soon became a favorite of many photographers and she never hesitated about taking her clothes off. Before long images of Bettie fall into the hands of brother-and-sister entrepreneurs Paula and Irving Klaw, who produce fetish photos, magazines, and 8- and 16-millimeter films for extra income. Bettie soon finds herself wearing leather corsets and thigh-high boots while wielding whips and chains for photographers. Bettie is innocently unaware of the sexual nature of the images that rapidly made her a star in the underground world of bondage fetishists.

Bettie's legendary fetish photos made her the target of a governmental investigation into pornography, and transformed her into an erotic icon who continues to be admired by many to this day.

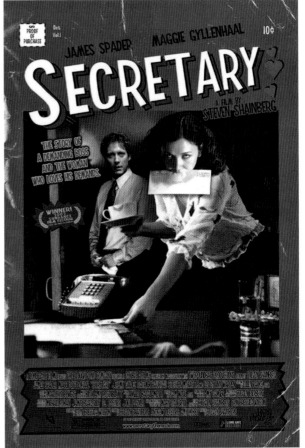

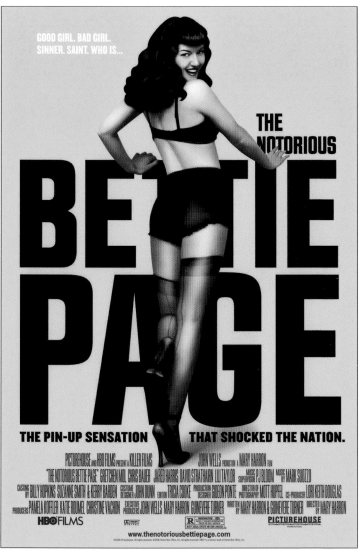

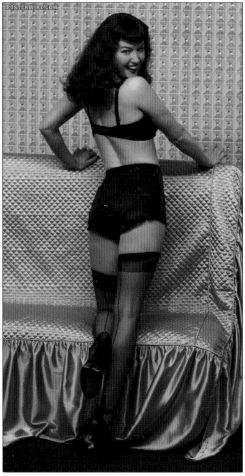

>>> Party time!

PARTY TIME!

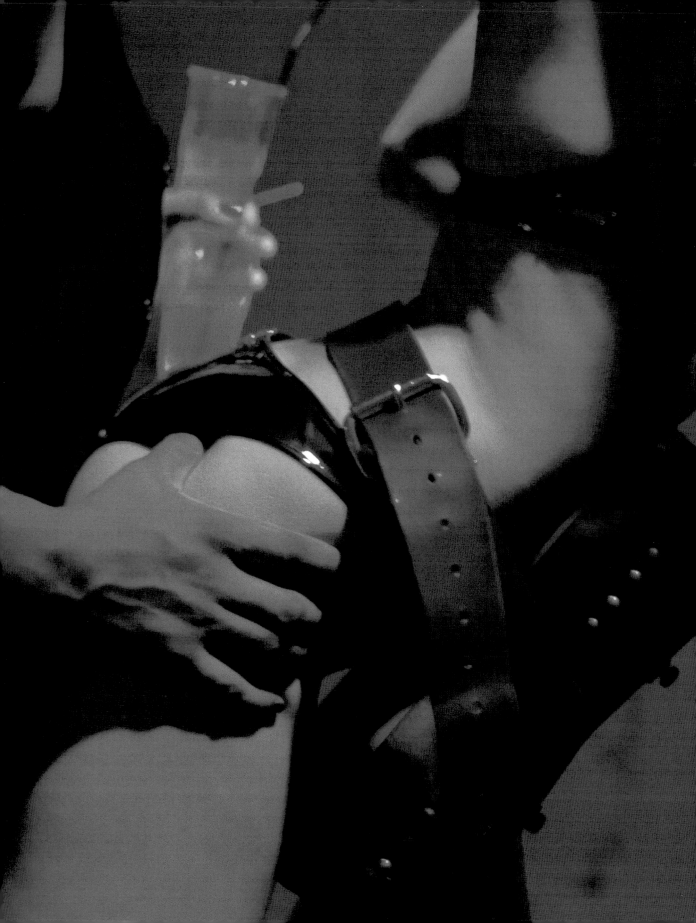

>>>

>>> Party time!

If you want to venture out of your home dungeon, here are some of the best fetish theme parties around.

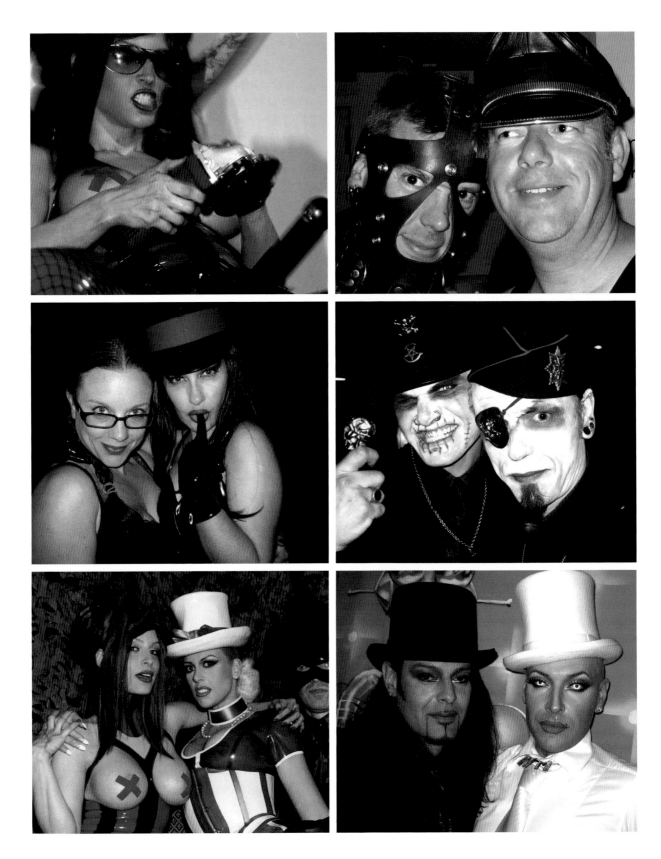

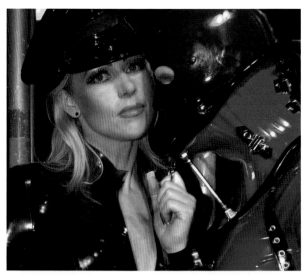

The Clinic
For over ten years, The Clinic Party in Amsterdam has been offering one of the best fetish events in Europe. The universal fetish event takes place twice a year: in June and in December. The Clinic also edit their own fetish magazine.
www.clinicparty.com

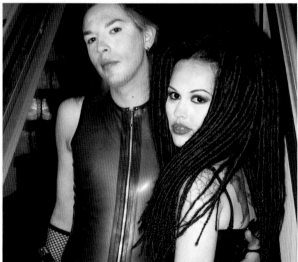

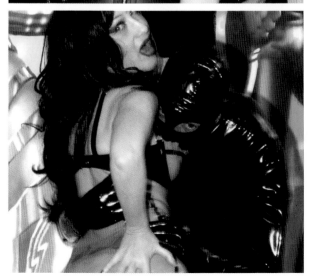

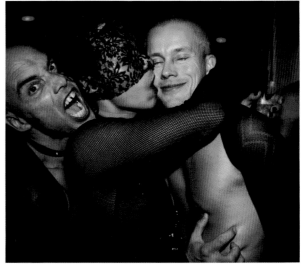

Wasteland

Wasteland in Amsterdam has been described as "The Super Bowl of Fetish" or as "Cirque du Soleil vs Marquis de Sade." Wasteland offers a wild night for fetish enthusiasts. Fetishwear is a must.

www.wasteland.nl

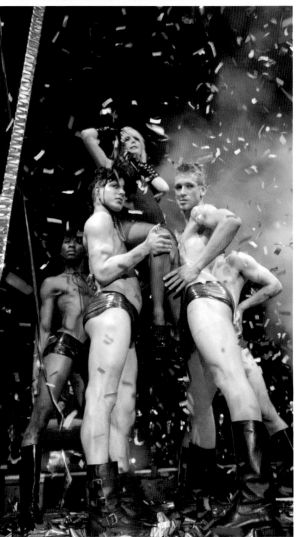

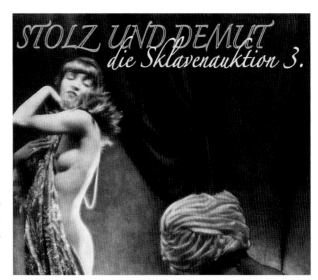

Stolz und Demut

Perhaps you have imagined that such a thing existed but never knew it was real. In Berlin Stolz und Demut offer a Slave Auction event once every three months. Check out the web for upcoming events.

www.stolzunddemut.com

Club Rub
One of the best fetish parties in London that takes place once a month. The club features fetish shows, house and techno music. and even has its own mistress.
www.club-rub.com

Rubber Ball

Latex lovers passing through London should not miss the Rubber Ball organised by *Skin Two*, one of the most successful fetish magazines around. The Rubber Ball is latex heaven.
www.skintworubberball.com

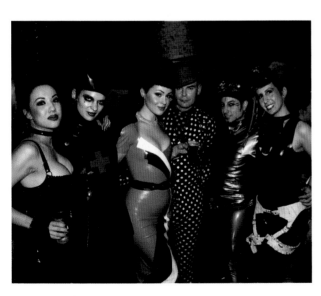

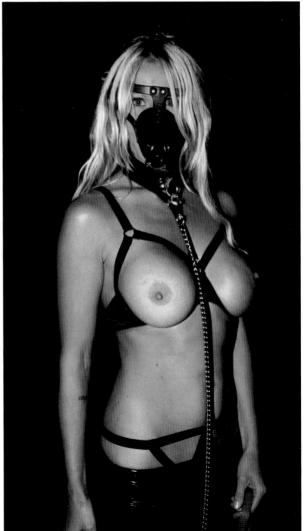

Torture Garden

Torture Garden in London started in 1990 and is now Europe's largest fetish club, featuring monthly at the Mass Club in the converted Saint Matthews Church, Brixton. It features dance floors, musical acts, performance art, fashion shows, and an S&M "dungeon." Torture Garden is also a top latex fetish fashion label and a production/performance agency.
www.torturegarden.com

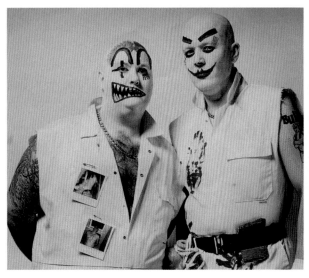
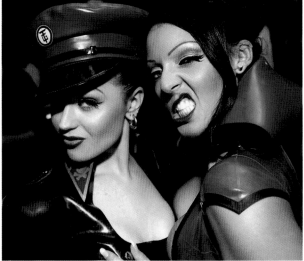

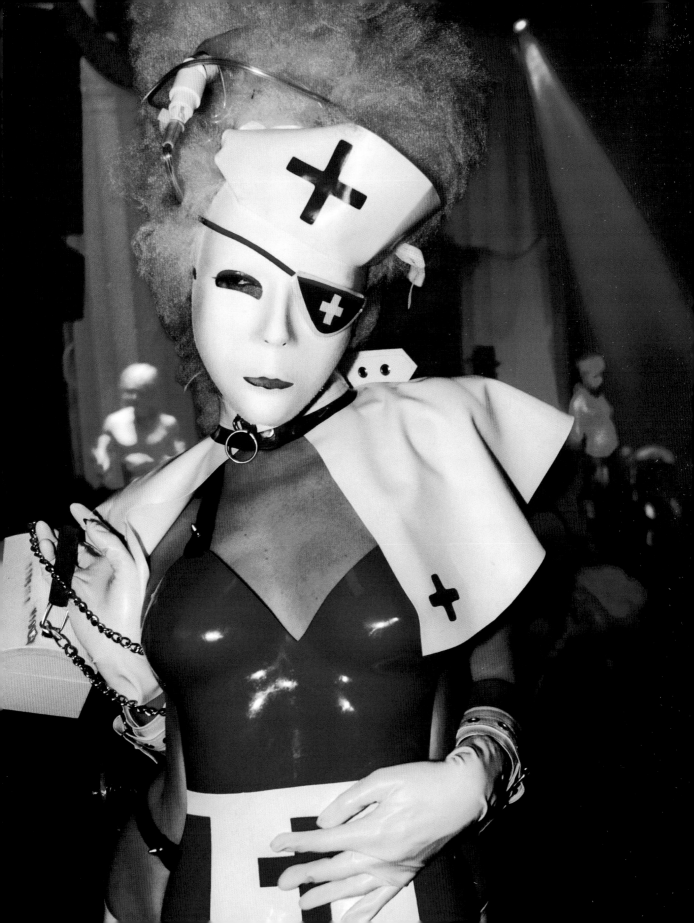

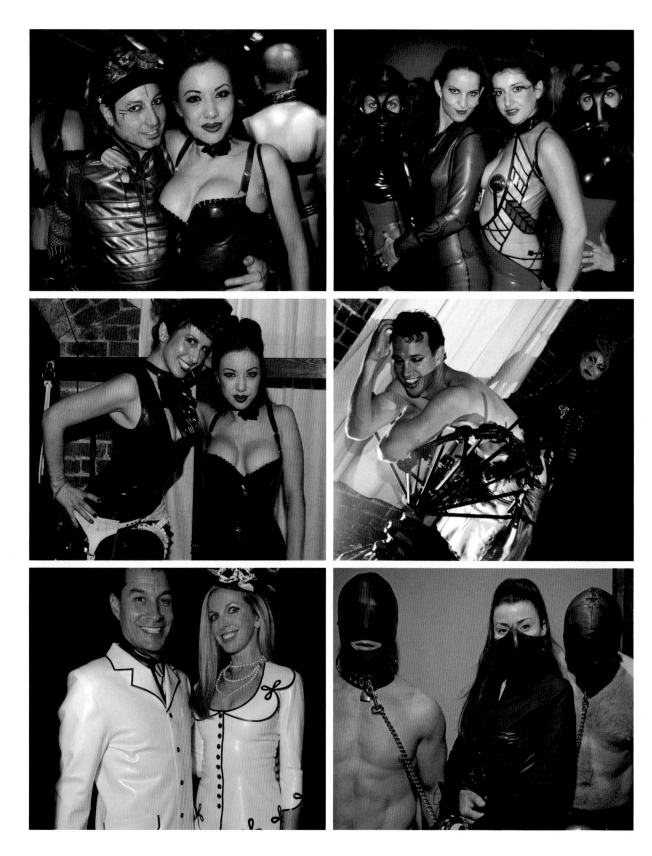

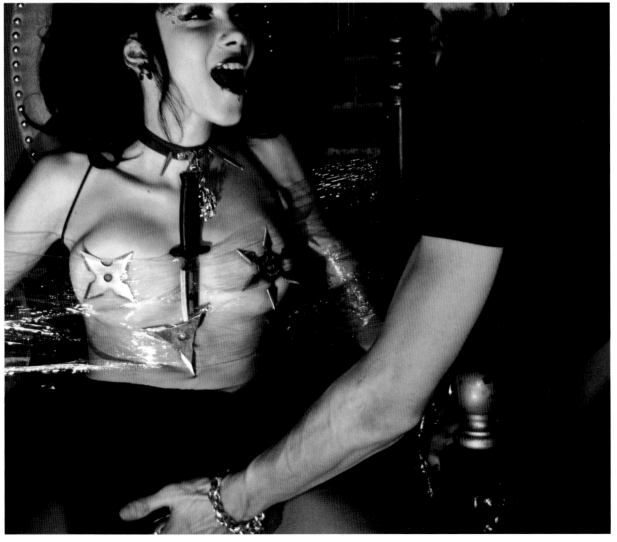

>>> Venus O'Hara

>>> Erika Lust

Venus O'Hara is a fetish model, actress and writer who currently lives in Barcelona. Born and educated in the United Kingdom, Venus O'Hara is a true internationalist who is fluent in French and Spanish after living and working in Paris and Madrid. Her modelling career began in 2005 when she joined a modelling agency, an experience that inspired her to start her own photoblog. She has since collaborated with many photographers and is actively involved in the styling of her photoshoots. With her ever changing style and perfect posing, Venus O'Hara has often been described as the girl with a hundred faces. She made her acting debut in the short film *Love Me Like You Hate Me* (2010), where she interprets seven different roles. She is currently writing and developing a screenplay for a new film adaptation of *Venus in Furs*.

www.venusohara.org

Erika Lust, born in Stockholm in 1977, currently resides in Barcelona, where she founded the production company Lust Films in 2004. She has managed to forge a name for herself as a producer, director, author and innovative feminist. Her first film, *Five Hot Stories for Her,* won several international awards including Best Script at the Barcelona Erotic Film Festival in 2007, Best Film for Women at the Erotic E-Line Awards (Berlin, 2007), an Honourable Best Mention at the CineKink Festival in New York (2008) and Best Film of the Year at the Feminist Porn Awards (Toronto, 2008).

She has also directed *Barcelona Sex Project* (2008), an outstanding erotic experimental film, and *Life Love Lust* (2010).

Erika Lust is also author of the acclaimed book *X: A Woman's Guide to Good Porn* and *Erotic Bible to Europe*.

www.erikalust.com

>>> Acknowledgments

Photography
Now You See Me, Now You Don't – Sebas Romero (www.sebas-romero.com)
Restraining the Maid – Guy Moberly
Bathroom Bondage – Guy Moberly
Legs – Andrew O'Hara
Catwoman – Sebas Romero (www.sebasromero.com)
Killer Heels – Antonio Martínez Galiot (www.jokerbcn.es)
Maria Betty (page 138)
Coco de Mer (pages 50 and 52)
Showtime – Antonio Martínez Galiot (www.jokerbcn.es)
Slave - Antonio Martínez Galiot (www.jokerbcn.es)
Slave Duties – Guy Moberly
Chaos – Sebas Romero (www.sebasromero.com)
Cold Water Punishment – Guy Moberly
Burlesque – David Vega (www.davidvegaphotography.com)
No Pain, No Gain – David Vega (www.davidvegaphotography.com)
La Fouetteuse – Antonio Martínez Galiot (www.jokerbcn.es)
Love Hurts – Juan Castaño (juancastanofoto.blogspot.com)
Love Me Like You Hate Me – Kristyan Geyr (geyrimages.com)

Art
Confession illustrations – Jan Serra (www.janserra.net)

Confessions
Adapted and edited by D. Robert Green aka *Gusano*

Miscellaneous
Thanks to Kitsch Barcelona for the fetish heels (www.kitsch.es)
Thanks to Bibian Blue for the Ivy corset (www.bibianblue.com)